IMAGES
of America

BAYSIDE

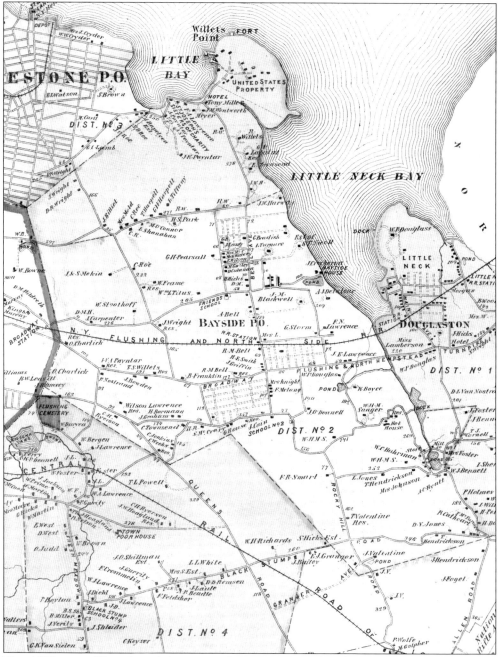

This 1870s map of Bayside and the surrounding area is typical of the period, as property owners and their residences are noted. By the time this map was delineated, the railroad had already been established for several years and Bell Avenue was a public thoroughfare. Fort Totten, however, was still known as either the Fort at Willet's Point or Camp Morgan, and Queens County had not yet become a borough of New York City.

On the cover: Please see page 15. (Courtesy of the Bayside Historical Society.)

IMAGES
of America

BAYSIDE

Alison McKay
with the Bayside Historical Society

ARCADIA
PUBLISHING

Published by Arcadia Publishing
Charleston SC, Chicago IL, Portsmouth NH, San Francisco CA

Printed in the United States of America

Library of Congress Catalog Card Number: 2008921571

For all general information contact Arcadia Publishing at:
Telephone 843-853-2070
Fax 843-853-0044
E-mail sales@arcadiapublishing.com
For customer service and orders:
Toll-Free 1-888-313-2665

Visit us on the Internet at www.arcadiapublishing.com

CONTENTS

ACKNOWLEDGMENTS

I would like to thank the individuals, families, and organizations that had the foresight to donate their photographs, documents, and memorabilia to the Bayside Historical Society archives so that we all may enjoy, benefit, and learn from them. I would also like to thank the following individuals for their time and assistance: Jennifer Dullahan; Joan Wettingfeld; Rose-Marie Harrison; John Hyslop, assistant division manager, Long Island Division, Queens Borough Public Library; Sharon Hull-Smith, head of special collections and archives, Brown-Daniel Library, Tennessee State University; Wendy Hurlock Baker from the Archives of American Art, Smithsonian Institution; and Julia Schoeck, president of the Douglaston/Little Neck Historical Society.

All photographs were culled from the Bayside Historical Society archival collection unless otherwise stated.

INTRODUCTION

Perhaps because it is situated along Little Neck Bay, Bayside has always been considered prime real estate. The history of the town begins roughly 4,000 years ago with the arrival of the earliest settlers, the Matinecock, whose name in an Algonquin dialect means "people of the hilly place." They were hunters and gatherers who flourished by the bay. It was an integral part of the Matinecock's existence, as they made currency called wampum from the shells found along the shore. They eventually settled in permanent encampments, as trade with the European arrivals was established

The documented history of those first European settlers is problematic, because in 1789, a 17-year-old slave named Nellie was accused of setting the fire that destroyed the records held in the home of Flushing town clerk Jeremiah Vanderbilt. The clerk had refused permission for Nellie to marry, and in her rage, she committed arson. The trial was prosecuted by New York State Attorney General Aaron Burr at the Queens County courthouse in September 1790. Burr found Nellie guilty and sentenced her to death by hanging. She was executed on October 15, 1790. As a result of the fire, historians have pieced together much of this area's early history through sources other than those official documents, which included most land deeds that were stored in Vanderbilt's home.

While much conjecture reigns over the pre-Colonial era of Bayside's history due to tenuous documentation, it is definitively known that the native chief, Mechowot, signed a bill of sale to the Dutch West India Company in 1639 for the entire region, extending from what is today Flushing all the way to Smithtown. Included in the sale was the stipulation that the Matinecocks be able to live on and use the land. Subsequently, Governor-general Willem Kieft, also of the Dutch West India Company, issued land grants to 18 Englishmen in 1645 for acreage in and around Bayside, with the majority of Bayside divided among John Lawrence, William Thorne, and Thomas Hicks.

The Lawrence family played a dominant role in Bayside and throughout the region during the Colonial era. Lawrence, an original patentee, served as the first alderman of New York City, and he was later appointed mayor of New York City in 1672 and again in 1691. Because Lawrence's only son (also named John) had no heirs, the entire area granted by the Dutch—extending from approximately Twenty-fourth Avenue to Northern Boulevard and from the bay to Francis Lewis Boulevard—fell to other members of the Lawrence family. Some family members sold their property; others, including Effingham Lawrence, remained in Bayside and contributed greatly to the prosperity of the community.

The arrival of Abraham Bell to Bayside in 1824 marked the beginning of a new era in the town's history, as the wealthy shipping merchant, who was originally from Ireland, established his business in Manhattan and purchased vast tracts of property in the area. Farming some of the land and

selling off other acreage, Bell and his descendents played an integral role in developing Bayside by defining the layout of the town. Additionally, the Bell family can also be included among a group of wealthy residents who donated parcels of their property for the benefit of the community. The Willet family also played a significant role in shaping Bayside, as a large expanse of their property was sold to the federal government so that a fort could be built for protection of the waterways and, ultimately, New York Harbor from invasion.

During the latter part of the 19th century, Bayside evolved into a recreational destination while retaining its rural charm. Many who took advantage of Bayside's amenities were from society's political and social elite. The arrival of the railroad eased travel, and accessibility was key to the development of the community. Bayside was also discovered to be an ideal location for both seasonal and permanent residents in the performing arts community. Numerous theatrical and silent film stars, as well as other professionals, chose Bayside for its convenient location near Manhattan and proximity to the famed Astoria Studios.

Although considered part of Flushing for much of the 19th century, most often Bayside was associated with the western end of Long Island. By 1898, the entirety of Queens County became part of New York City, and Bayside, along with its eastern neighbors Little Neck and Douglaston, was absorbed into the borough. By 1910, direct train service to Penn Station ordained Bayside a commuter town that offered many amenities to country living within an easy half-hour commute to Manhattan.

Perhaps the most significant event that changed Bayside was the construction of the Cross Island Parkway, which opened in 1939. Built by the City of New York under the direction of Robert Moses, the parkway severed the bay from the community, with large estates and homes along the shore losing their riparian rights to the water. The Bayside Yacht Club similarly suffered, and although a public marina was built in its place, the town's appeal as a recreational destination was lost forever. Further altering the community was another highway construction project two decades later. The path of the Clearview Expressway cut during the 1950s bisected Bayside and necessitated the removal of hundreds of homes.

Despite these changes or perhaps as a result of them, the community's resolve has strengthened and its resilience appears boundless. Today Bayside is still considered prime real estate and a choice location in which to live, work, play, and raise a family just as it was at its inception.

One

THE ALLEY

The Alley is a large tract of land nestled between present-day Bayside to the west and Douglaston to the east. John Hicks, one of the original 18 Englishmen who received a land grant from the Dutch in 1645, owned a substantial portion of the Alley, as well as the adjoining parcel later known as the Oaks.

The Alley extended from Little Neck Bay to as far south as the present-day Long Island Expressway and Cross Island Parkway interchange. The Alley could have been given its descriptive name owing to its topography. The marshy valley and Alley Creek form a kind of low-lying corridor. The name may also have been derived from its use by travelers as a kind of passage or alley, as this was the main route taken by travelers journeying to destinations both east and west by land and by sea, accessible via Alley Creek and Little Neck Bay. George Washington is said to have taken a route through the Alley during his tour of Long Island in 1790.

Throughout the 19th century, the Alley maintained its bucolic quality while also becoming a trading center with a general store, blacksmith shop, grist- and wool mills, and a post office. By 1908, William Vanderbilt continued the tradition of the Alley as a traveler's passage, as his privately owned and operated Long Island Motor Parkway ran through a section of it. Today this region in Northeast Queens is part of Alley Pond Park.

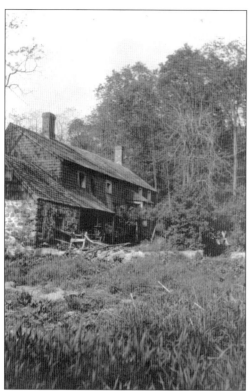

This photograph shows the homestead that belonged to Thomas Foster in the Alley. In some accounts, Thomas Foster is credited as the first homesteader in the Alley. While John Hicks received a 600-acre land grant from the Dutch West India Company in 1645, there is no documentation confirming any settlers who claimed territory prior to that date.

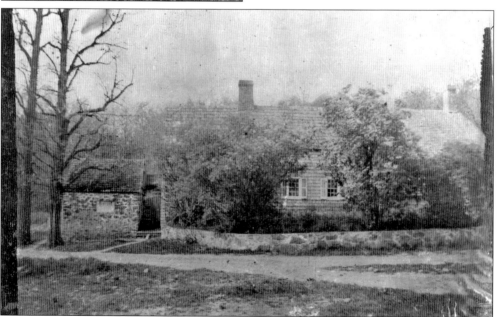

Although the date as to when Foster actually settled in the Alley is tenuous, he built a one-room stone cottage in the mid-17th century near where Northern Boulevard is located today. The cottage was expanded greatly in subsequent decades and was reported to have fallen siege to looting Hessians during the Revolutionary War. Seven generations of Fosters lived at the homestead before it fell into disrepair.

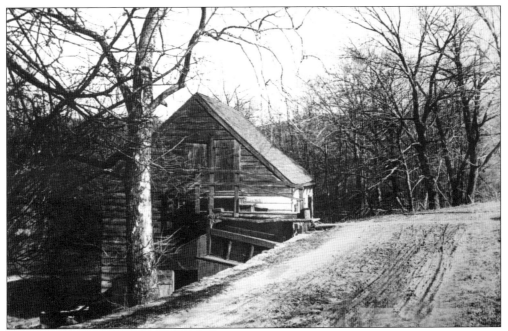

It is believed that this gristmill was built by James Hedges some time during the Revolutionary War. This image from 1906 shows the mill in dire condition. It is representative of how the Alley remained rural and declined as a center of commerce while Bayside and the neighboring towns developed around it. The mill was destroyed by fire in 1926.

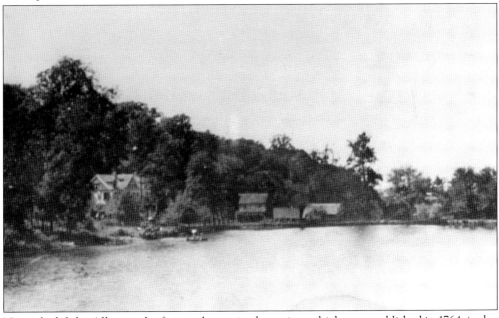

Not only did the Alley see the first mail route in the region, which was established in 1764, it also became the site of the first commercial enterprises in the area. Several mills were constructed along Alley Creek, including mills operated by Thomas Hicks, Thomas Foster, and James Hedges. This view from 1906 depicts the Buhrman property with a homestead, general store, mill, and barn along Alley Pond.

Alley Pond's reputation as a bucolic haven is evident in this photograph from the middle of the 20th century. The pond was created as a result of early settlers damming Alley Creek (the stream that flows from Little Neck Bay) in order to harness power for their gristmills. Today a substantially smaller Alley Pond remains, as much of it is was filled in and covered by the Long Island Expressway and Cross Island Parkway cloverleaf.

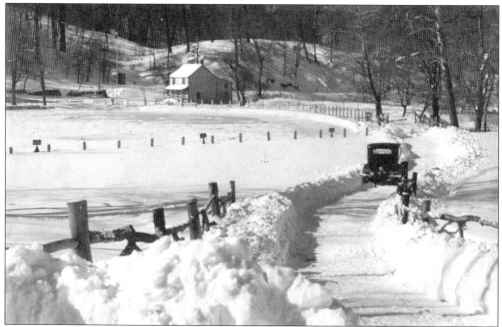

This photograph, taken around 1930, shows Alley Pond after the first major snowstorm of the season. The narrow road leads to Buhrman's General Store, which was, by then, no longer in operation. Other structures along the pond, including Buhrman's mill, were demolished in 1929 by the New York City Parks Department after its acquisition of the property.

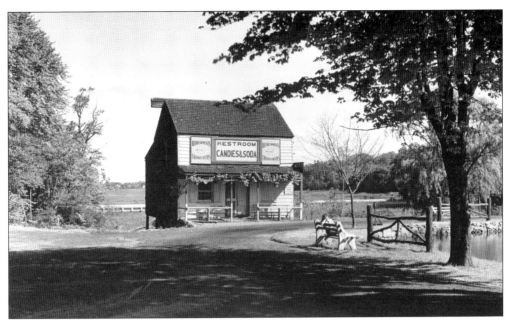

Buhrman's General Store opened in 1828, establishing it as the first trading post in northeastern Queens. The store flourished for many decades because it carried goods and sundries needed by both locals and travelers passing through the Alley. The original proprietor, Benjamin Lowerre, a former innkeeper from Flushing, ran the store for 11 years. He subsequently sold it to his son-in-law William C. Buhrman on April 30, 1839.

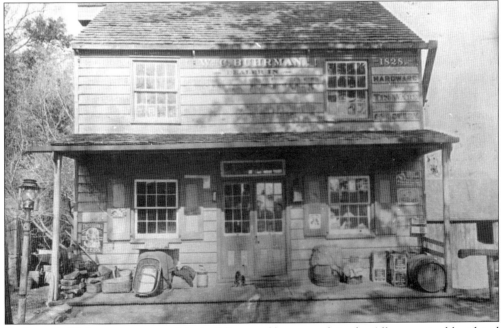

By the early 20th century, most of the buildings and homesteads in the Alley were in dilapidated condition, including Buhrman's General Store, seen in this photograph from the 1920s. The New York City Parks Department acquired the land in 1929 and converted much of the area into a park that officially opened to the public in 1935.

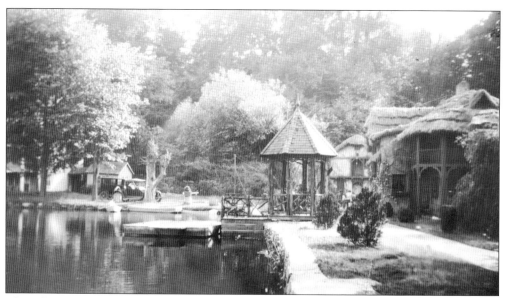

The Alley was the backdrop for the filming of the 1923 movie *ZaZa*, starring Gloria Swanson. As the story's setting takes place in an open-air theater in a small French village, Alley Pond and its surrounding environs were ideal locations.

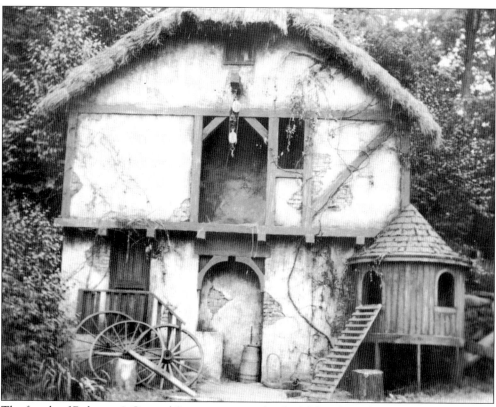

The facade of Buhrman's General Store was covered to look like a French provincial barn during the filming of *ZaZa* in 1923.

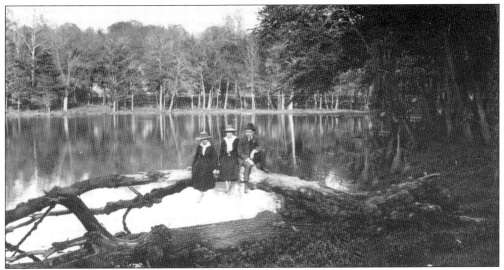

The idyllic setting of Alley Pond was a popular backdrop for informal group photographs, such as this one from 1908 of Georgia Knight (left) and two unidentified friends. At the beginning of the 20th century, Alley Pond was considered a pleasant recreational site and picnic spot rather than the commercial area it had been decades before.

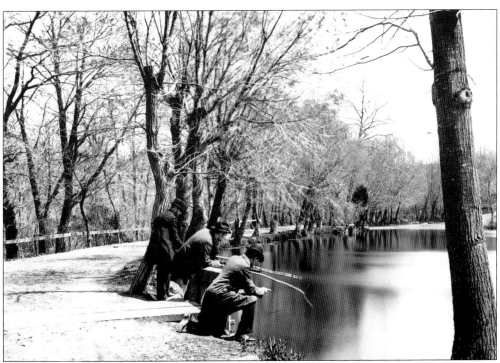

Fishing in Alley Pond was a favorite pastime of area locals, as seen in this photograph from 1900. Although originally larger than nearby Oakland Lake, the pond was severely reduced in size after construction of the Cross Island Parkway and Long Island Expressway interchange. (Courtesy of the Queens Borough Public Library, Long Island Division, Hal. B. Fullerton Photographs.)

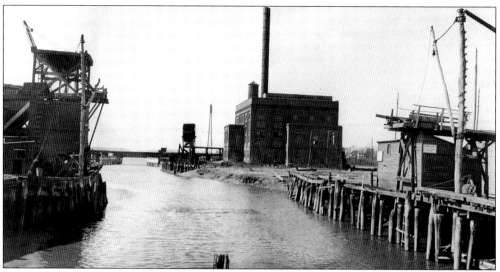

Alley Creek provided a route for seafaring ships to navigate down, allowing barges and sloops to bring supplies and manufactured goods from Manhattan and elsewhere to the Alley and surrounding farms. The Alley's viability as a commercial hub faltered as a result of damming Alley Creek by millers. Its demise was furthered with the construction of a wooden bridge, built in 1826 by Wynant Van Zandt over Alley Creek to ease the route between his Douglaston estate and Flushing. The bridge blocked passage of larger ships, greatly crippling trade. This view of Alley Creek from the Northern Boulevard bridge is from 1927. (Courtesy of the Queens Borough Public Library, Long Island Division, Eugene Armbruster Photographs.)

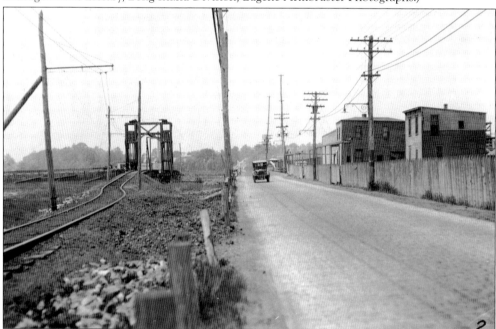

By the 1860s, the Long Island Rail Road extended service from Flushing to Great Neck and constructed a berm upon which tracks were laid that interrupted the flow of Alley Creek. Van Zandt's route, which is present-day Northern Boulevard, and the berm for the tracks are evident in this photograph from 1908. (Courtesy of the Douglaston/Little Neck Historical Society.)

Two

BELL BOULEVARD

Previously called Bell Avenue, the road began as a private, unpaved lane dividing the upper and lower sections of the 245-acre Bell Farm that Abraham Bell I purchased from Timothy Matlock in 1824. As portions of the farm were sold off in subsequent years, the road was extended and widened. In 1866, Robert Bell, the nephew of Abraham Bell, donated a portion of the property at approximately Forty-first Avenue and Bell Boulevard for the construction of a railroad station that, at the time, had its terminus in Great Neck.

The development of Bell Boulevard as a commercial district flourished during the early part of the 20th century and had a concentration of businesses and merchants from Broadway (Northern Boulevard) to the railroad station at Ahles Place (Forty-first Avenue). Bell Boulevard continued to develop as a viable business district, main thoroughfare, and social hub of Bayside throughout the 20th century. With the support, programs, and improvements offered by the Bayside Business Association that is headquartered in the old Long Island Rail Road freight building on the boulevard, the street continues to grow and attract new businesses.

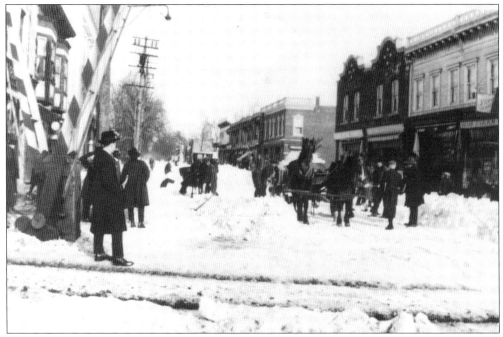

Bell Boulevard's growth was directly linked to transportation. The central business district developed first near the railroad station built in 1866 at Elsie Place (Forty-first Avenue). In this photograph, the tracks can be seen running on an east–west axis at grade level.

Work began in 1929 to eliminate the train tracks that ran across Bell Boulevard and depress them below grade level, as seen in this photograph that was taken at roughly the same location as the one above. (Courtesy of the Queens Borough Public Library, Long Island Division, Public Service Commission Collection.)

John Hope ran his grocery, hay, and feed store on the corner of Bell and Forty-second Avenues for more than 40 years with his sister Annie, as seen in this photograph from about 1895. Hope bought the store in 1885 for a purported $750 and stocked it to capacity, carrying everything from horse oats to dishware. Hope died in 1926 and his heirs sold the property. The wooden building was replaced with a brick structure in 1928, and a butcher shop moved in as the first tenant.

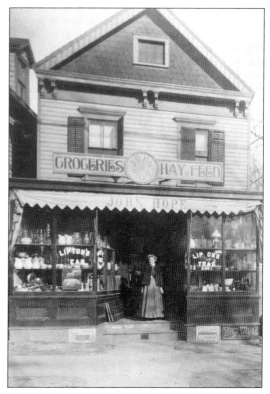

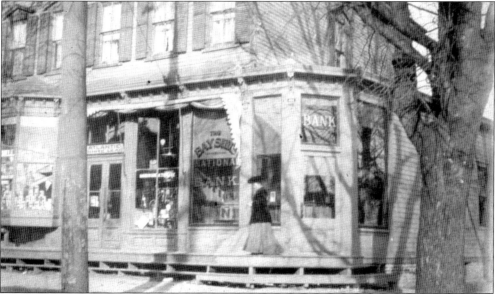

Originally used by the Straiton and Storm cigar factory, Bayside's first bank opened on the northeast corner of Bell and Lawrence Boulevards (Forty-third Avenue). Started by Frederick Storm, Bayside National Bank officially opened for business in 1903 and had its beginnings as a desk in the back of the store that Storm rented to Collin's Grocery. By the 1920s, the bank moved into a new building located across the street. It was sold to Bank of the Manhattan Company on October 28, 1928.

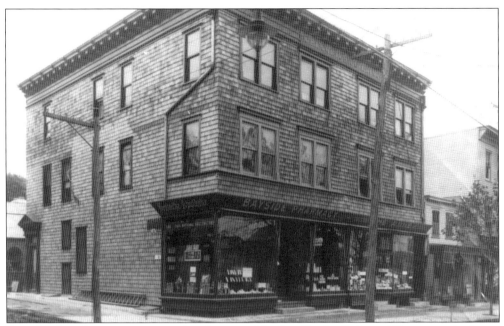

Bayside's first pharmacy was owned and operated by Dr. Charles B. Story. The store, which was located on the northwest corner of Bell Boulevard and Ahles Place (Forty-first Avenue), sold medicine, toiletries, perfumes, and cigars. Story graduated from Cornell University in 1886 and opened his Bayside practice in 1890. As a member of the Bayside Yacht Club, Story was also appointed fleet surgeon but is best remembered as the chief surgeon and as a founding member of Flushing Hospital.

The cigar store seen in this postcard was attached to Story's pharmacy building, located on the northwest corner of Bell Avenue and Ahles Place (Forty-first Avenue). As road supervisor, Abraham Bell II (1841–1914) was involved with the naming of Bayside's streets, boulevards, and avenues prior to the establishment of a numerical street system by the U.S. Postal Service in 1916. Ahles Place was named for John W. Ahles. He married Bell's cousin, Lillian Bell, in 1873.

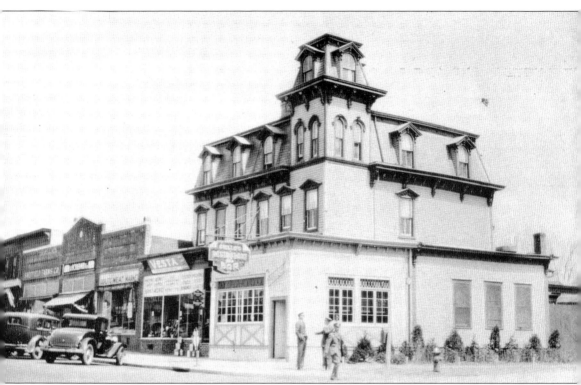

The three-story building belonging to Straiton and Storm Cigar Manufacturers towered over the other buildings along Bell Avenue. Built around 1872, it originally was used as the company's factory and held a bay of seven garages in the rear. Straiton and Storm Cigar Manufacturers was one of the largest cigar producers in the country. In 1877, the Manhattan factory was involved in labor disputes that resulted in rioting employees and a strike that lasted 107 days. Its president, George Storm, expanded the company greatly through his purchase of four tobacco plantations in Florida. He later moved the company's headquarters and factory into Manhattan. It eventually became the Owl Commercial Company and then American Tobacco Company. Its original building at the east side of Bell Avenue and Park Avenue (Forty-second Avenue) served various businesses through the years. The building was destroyed by fire in 1990.

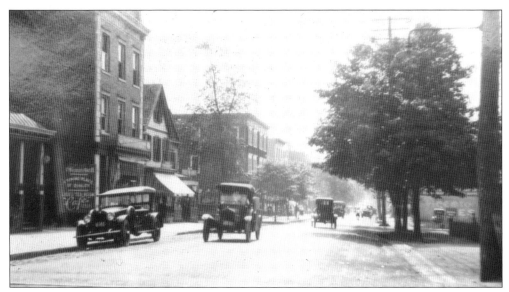

This view of Bell Boulevard looking south at Ashburton Avenue (Thirty-ninth Avenue) was taken in 1916 and features the tracks that Bayside's trolley ran along. Operated by the New York and North Shore Traction Company for 10 years, the trolley line ran from Flushing to Port Washington, linking the Flushing/Bayside division with the Nassau County division. Although it cost only a nickel to ride, New York City's board of estimates refused to allow a fare increase in 1915. As a result, the trolley company was plagued by financial difficulties and was forced to cease operations in the summer of 1920.

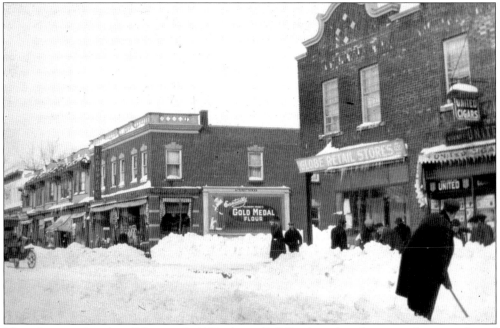

This photograph, taken February 8, 1920, shows Bell Boulevard under more than two feet of snow after a three-day storm. The *New York Times* deemed it the worst storm in the region's history, topping the infamous 1888 event, as the mix of precipitation made it extremely difficult to shovel and hindered clean-up efforts.

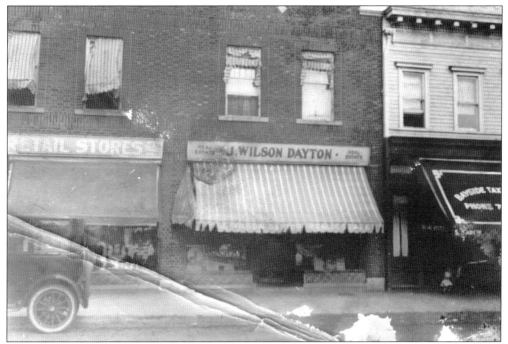

J. Wilson Dayton began his career as an assistant to his father, Bayside homebuilder John Dayton. J. Wilson opened his first real estate office in 1907 on Bell Avenue and founded the Dayton Real Estate Agency in 1914. This photograph from about 1920 shows the original location of his office on the east side of Bell Boulevard at Forty-first Avenue.

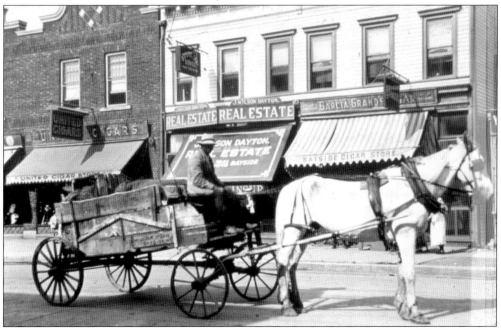

This photograph, taken the same year as the one above, shows local garbage hauler William Hayes with his horse and cart on Bell Avenue. The real estate office of J. Wilson Dayton, flanked by two cigar stores, can be seen behind him.

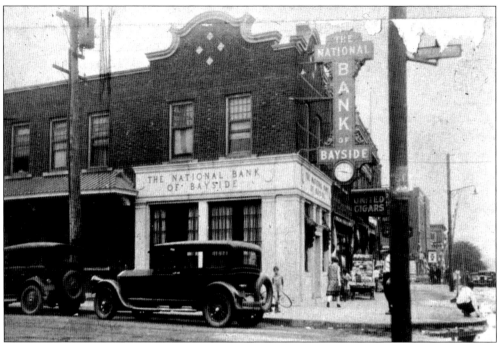

A year after Frederick Storm's bank was sold to the Bank of the Manhattan Company, Baysiders J. Wilson Dayton, Henry Doughty, Edward Mandell, and others launched the National Bank of Bayside. The name was later changed to the one Storm used, Bayside National Bank, when the trademark owned by the Bank of Manhattan Company expired. By January 1953, the bank was sold to Manufacturers Trust Company. The bank was located on Bell Boulevard and Elsie Place (Forty-first Avenue), and the photograph showing the bank interior was taken on opening day in 1929.

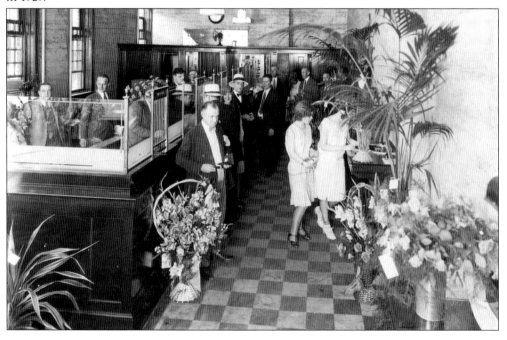

On the northwest corner of Bell Boulevard and Crocheron Avenue (Thirty-fifth Avenue) was Murphy's Hotel, seen in this photograph from 1922. Later the structure was moved further west on the property in order to make way for a corner gasoline station. (Courtesy of the Queens Borough Public Library, Long Island Division, Eugene Armbruster Photographs.)

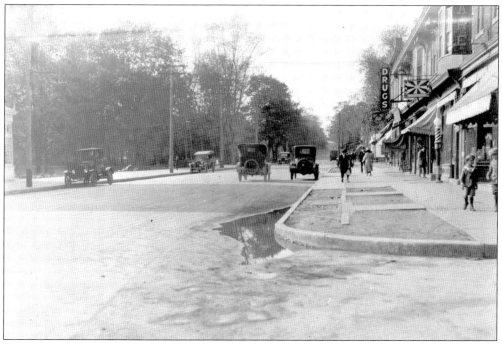

This photograph was taken around 1920 on the corner of Bell and Montauk Avenue (Fortieth Avenue). The growth of the business district was a gradual process, as the east side of Bell Avenue developed first and then gradually grew northward.

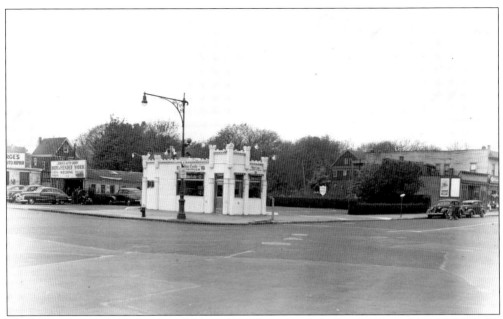

Located at the northwest corner of Bell and Northern Boulevards since September 10, 1932, the original White Castle building seen here was fashioned after the Chicago Water Tower, which survived the great fire of 1871. It was the seventh White Castle to open in the United States, and as a mainstay on this busy commercial intersection, the fast-food restaurant was expanded and remodeled several times over the decades.

This convenience store, called the Shack, was started by Avery Leland and John Mason in 1933. The business venture began as a chicken coop on the vacant lot at the southwest corner of Thirty-fifth Avenue and Bell Boulevard. The store grew in size and was eventually sold to Helen Klein, who ran it with her children Lucy Klein and Monroe Klein. This photograph was taken in 1949. The Shack was demolished in 1960.

Mary and Joseph McElory ran their restaurant and tavern on Bell Boulevard for over 50 years. This photograph from the early 1930s shows McElroy's facade with the main entrance opening into the bar area. Once inside, two sections were divided by swinging doors so as to accommodate two distinct clienteles. The restaurant catered to businessmen, while the bar area was frequented by young adults who ate hamburgers on white bread prepared by McElroy's cook of nearly 20 years, Wong Chaung.

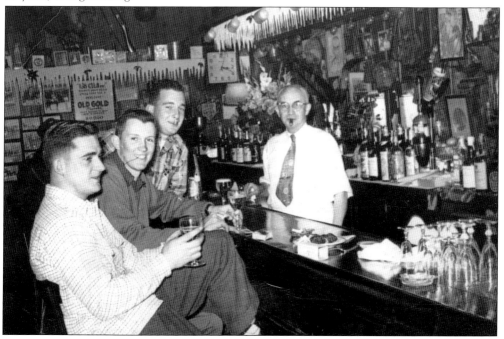

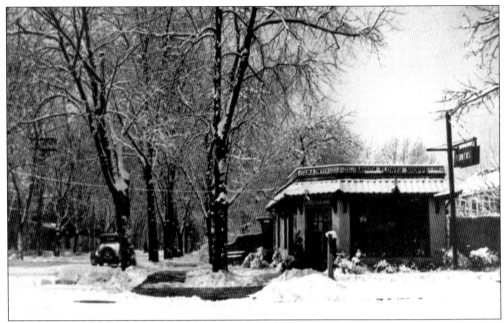

Opened in 1925, Dywer's Flower Shop was located on Bell Boulevard and Ashburton Avenue (Thirty-ninth Avenue). The store was owned by Marie Dwyer, the daughter of farmer and florist Eugene Bechamps, whose business was located on Rocky Hill Road (Forty-eighth Avenue). Dwyer and her husband, John J., raised three daughters and a son in a large house on Fifth Street (217th Street).

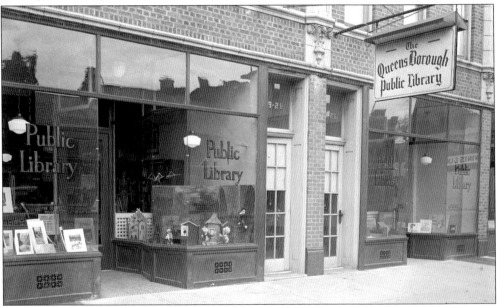

Bayside's public library on Elsie Place (Forty-first Avenue) relocated to Bell Boulevard in 1935. The storefront location allowed for window displays that were designed to educate and draw the public into the library. It remained at this location until 1965 when it was moved to Northern Boulevard. (Courtesy of the Queens Borough Public Library, Long Island Division, Queens Borough Public Library Collection.)

The Bayside Movie Theater, located on the corner of Bell and Thirty-ninth Avenues, was the backdrop for this 1942 photograph of inductees by the local draft board. Built in 1929 by famed theater architect and Bayside resident, Thomas W. Lamb (1871–1942), the movie house was originally named the Capitol Theater. Although it was divided into a multiplex with four screens in the 1970s, by 2000 it had ceased operating as a movie theater and is now occupied by retail stores.

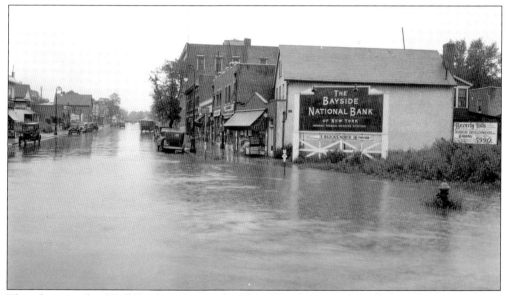

This photograph of Bell Boulevard was taken from Northern Boulevard after a hurricane swept through the area on September 15, 1933. Flooding forced many businesses to close until the waters receded. (Courtesy of the Queens Borough Public Library, Long Island Division, Borough President of Queens Collection.)

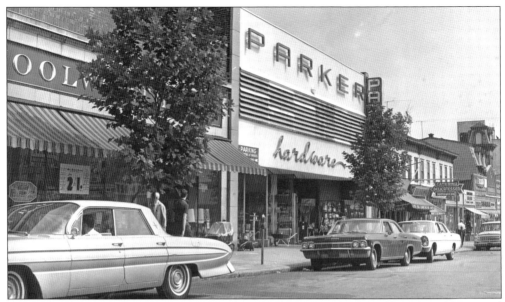

Parker's Hardware Store was in business on Bell Boulevard for 83 years and has recently returned after moving out of Bayside for several years. Pauline and William Parker opened their store in 1908, and by the 1960s, they passed it on to two of their four children, Celica Greenfield and Edward Parker. Greenfield and Parker ran it for 30 more years until their retirement in 1990, when they passed it to their longtime employee, Thomas Brigt. This photograph was taken in 1969 on the store's 60th anniversary.

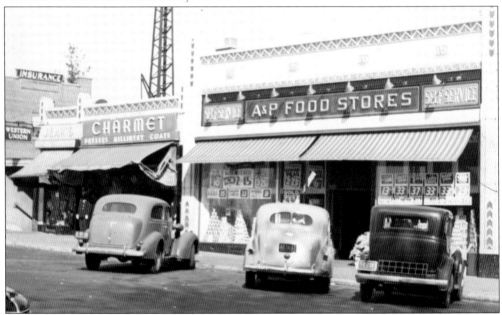

Located on the east side of Bell Boulevard between Forty-first and Forty-second Avenues were Charmet and the A&P grocery store. Specializing in women's wear and bridal fashion, Charmet had been a feature on the boulevard for over half a century, while other stores, such as the A&P, came and went. Kurtzberg's Stationery Store was in the location for many years after the A&P moved out, and Charmet has recently been replaced by a nail salon.

Three

ESTATES, MANSIONS, AND HOMESTEADS

The first mention of the town's name appeared on early maps denoting the Lawrence property as situated on the Bay Side. Although the town was a farming community for its first 200 years, the natural beauty found along Little Neck Bay was a major factor in its attraction for many wealthy individuals. Transportation also contributed to this phenomenon. Daily coach service from points west began in 1840, and the railroad, which first came to Bayside in 1866, had daily stops by the 1870s. The railroad service provided easier access from New York City via the Long Island City ferry, which departed from 34th Street in Manhattan. When the Queensborough Bridge was completed in 1909, it made the commute even easier.

Many of the wealthy residents in the 19th century considered themselves gentleman farmers and pursued other careers while maintaining orchards, groves, or sheep farms in Bayside. Others, including some members of the Bell family, maintained two or more residences and divided their time between Bayside and Manhattan on a seasonal basis. Still others, such as Louis Harway and Fredrick Storm, made their fortunes close to home.

It was not until the early years of the 20th century that the demise of these large estates was imminent. Many factors contributed, but ultimately, most were for financial reasons. Nearly all of the mansions, homesteads, and estates were razed with the acreage subdivided for residential development.

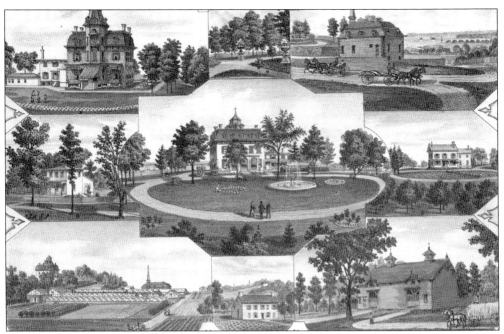

The John Taylor estate, known as the Oaks, was originally a nursery run by the Hicks family. The property was sold to a member of the Lawrence family who in turn sold it to Taylor in 1859. As suppliers of plants and cut flowers, Taylor and his partner, John Henderson, created one of the largest horticultural businesses of the period. They constructed 24 greenhouses warmed by hot-water pipes running over an acre on the estate. The name of the property is believed to have been derived from the trees in the area, first introduced by the original European settler, John Hicks.

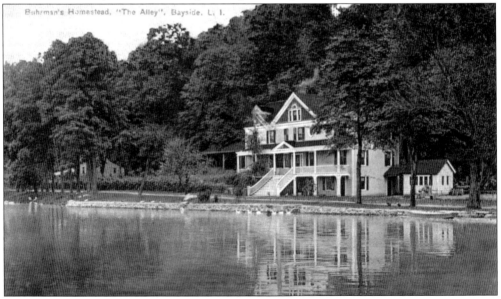

The homestead of William Buhrman and his wife, Mary E. Lowerre Buhrman, was located along Alley Pond next to their general store and gristmill, as seen in this postcard from 1908. In early years, a pine tree reaching over 50 feet tall was allowed to grow directly through the steps leading up to the front porch.

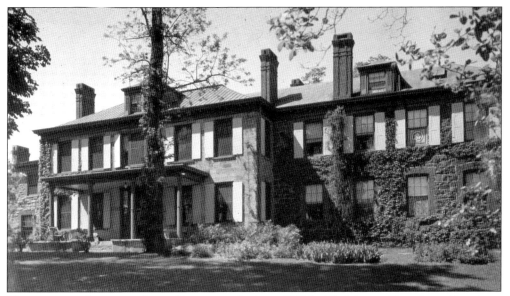

This mansion, known as Stone House, was built in 1822 by Flushing resident Isaac Stansbury for Judge Effingham Lawrence. Located at 39–19 222nd Street, Stone House was situated on 49 acres overlooking Little Neck Bay. Passing to Lawrence's eldest daughter, Lydia Lawrence, the property was owned by her until her death in 1879. She then left the mansion to her only son, Col. Fredrick Newbold Lawrence, from her marriage to her first cousin Edwin Newbold Lawrence. It was the colonel who expanded the mansion by adding a wing with a dining room able to accommodate 80 guests. Upon his death in 1916, Stone House was left unoccupied. By 1924, the mansion was sold to Emma Foster, who passed it to her niece Clara Kouwenhoven. In 1956, the property was sold to developers and Stone House was demolished.

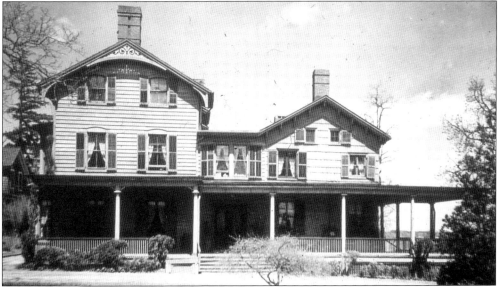

This Victorian-style farmhouse was home to nine generations of the Lawrence family. It was originally much larger, but Effingham Lawrence dismantled part of it in 1822 in order to use the massive beams for his mansion, Stone House. An addition on the homestead was built in 1878 with a wrap-around porch that dramatically altered the facade.

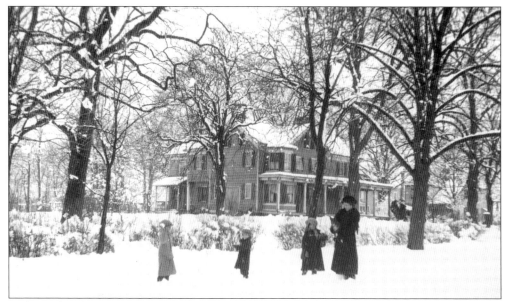

Melissa Chambers Bell (right) and her children are seen in front of the house that was originally built by her grandfather-in-law Abraham Bell I. The home was situated on the northwest corner of Bell and Warburton Avenues (Thirty-eighth Avenue) and became the property of Thomas Bell through inheritance when Abraham died in 1849. Melissa Bell was the wife of Abraham Bell II, the son of Thomas Bell and grandson of Abraham I.

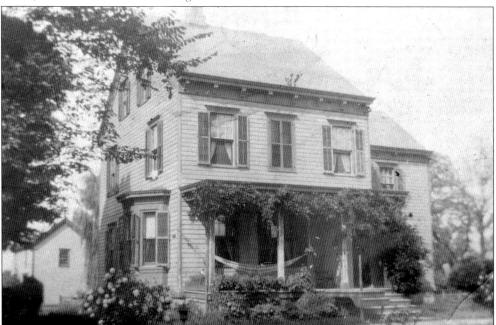

Abraham Bell II built this home in 1870 as a wedding present for his bride to be, Melissa Chambers. The home was located across the street from Abraham Bell I on the southwest corner of Bell and Warburton Avenues (Thirty-eighth Avenue). Their children grew up in this house, and upon its sale in 1969, the house was razed and the property now has a commercial office building.

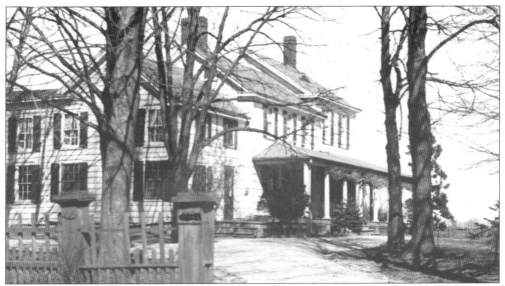

Referred to as the Cornell-Appleton House, this is one of the oldest surviving homes in Bayside, as it is believed to have been built around 1790. Located on 214th Place, the original structure was built by John Allen (died 1815). Allen owned 164 acres, with the property transferring to Archibald Cornell (died 1852) through his wife, Elizabeth Allen, upon the death of her father in 1815. It was Cornell who added the second wing to the original farmhouse in 1820, with the third and largest addition built by Edward D. Appleton after he purchased the property in 1905.

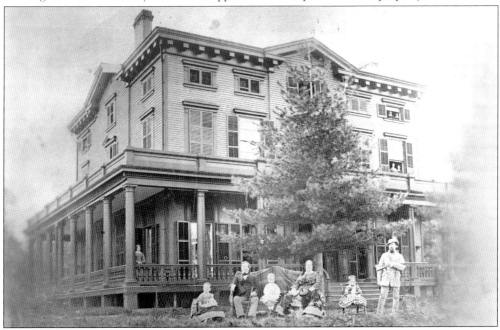

After serving one term as mayor of New York, from 1845 to 1847, Andrew H. Mickel (1802–1863) purchased land from Abraham Bell I in 1849 and moved into his estate, known as Bay Lawn. The property was located between what is now Thirty-sixth and Thirty-eighth Avenues and 218th and 219th Streets. Mickel, a wealthy tobacco farmer, married Judge Effingham Lawrence's second daughter, Mary Nicoll Lawrence. Fire destroyed Bay Lawn in 1890.

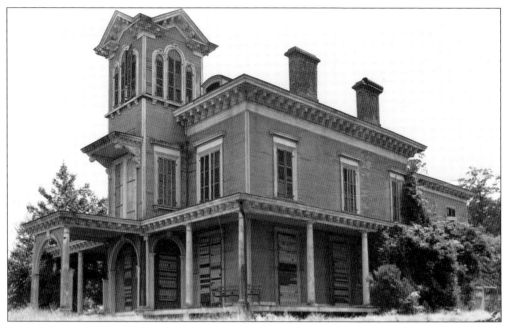

Referred to as either the Ker Boyce mansion or Palmetto, this 18-room home built prior to the Civil War was situated on the southeastern side of Oakland Lake. While records are tenuous, the mansion had ties to the Lawrence family because Frederick Newbold Lawrence married Elizabeth Miller in 1855. She was the youngest daughter of Kerr Boyce, a South Carolina legislator and president of the Bank of Charleston. Another Lawrence family member, Lydia Lawrence, had at one time lived on the estate with her husband, Rev. George W. Eccles of St. John's Episcopal Church in Flushing. The mansion sat idle for many years and was destroyed by fire in 1936.

This home, located at 39–26 213th Street, known as Ahles House, was built in 1873 by Robert Bell as a wedding gift to his daughter Lillian Bell and son-in-law John Ahles (1847–1915). Ahles was a successful grain merchant and member of the New York Produce Exchange for more than 20 years. The couple raised two daughters and a son on this estate. Ahles Place, now Forty-first Avenue, was named in his honor.

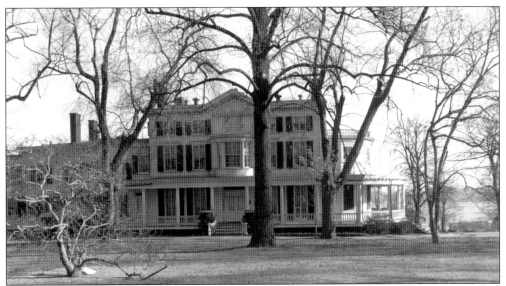

Known as Shore Acres, this mansion was built by Robert Willet in 1853 on what is now approximately Eighteenth Avenue and Bell Boulevard. Willet's father, Charles Willet, purchased the property in 1829 from Jacob Thorne and Thorne's Neck was renamed Willets Point. In 1899, Shore Acres was inherited by Robert's daughter, Amelia, and her husband, A. Howland Leavitt. In 1923, the estate was transferred to Leavitt's daughter Sarah and her husband, Charles Garrison Meyer. The property was sold in 1939 and is now a highly developed residential and commercial area in Bayside. The mansion was demolished in 1963.

Known as the "Cypress Lumber King," William L. Burton purchased 54 acres from H. W. Leavitt in 1906 and built this 15-room mansion at an estimated cost of $200,000. In 1936, the property was sold to Walter Ring for $350,000. Although Ring intended to build 400 homes on the site while keeping the mansion for himself, the plans fell through and the property was eventually acquired by the Sylvania Corporation. Used as a research center until General Telephone and Electronics Corporation (GTE) relocated to Massachusetts, the property was again sold and is the current site of the Baybridge Condominium development.

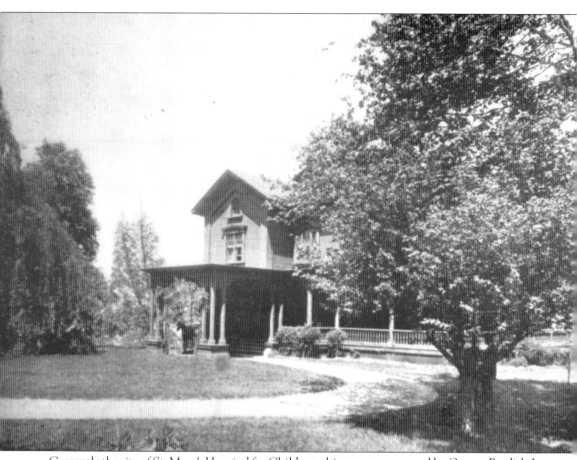

Currently the site of St. Mary's Hospital for Children, this estate was owned by George Bradish Jr. who was born into a wealthy and socially connected family. Bradish was an only child and received the entirety of his father's fortune when he came of age. He moved to Bayside with his wife, Elizabeth J. Johnston, during the Civil War and was known for his volunteer work with wounded soldiers at Camp Morgan on Willet's Point (Fort Totten). Bradish and his wife were the talk of Bayside gossip when she brought a civil suit against him in 1891, seeking a legal separation and funds in order to support her Manhattan lifestyle when she and their two children left Bradish in Bayside.

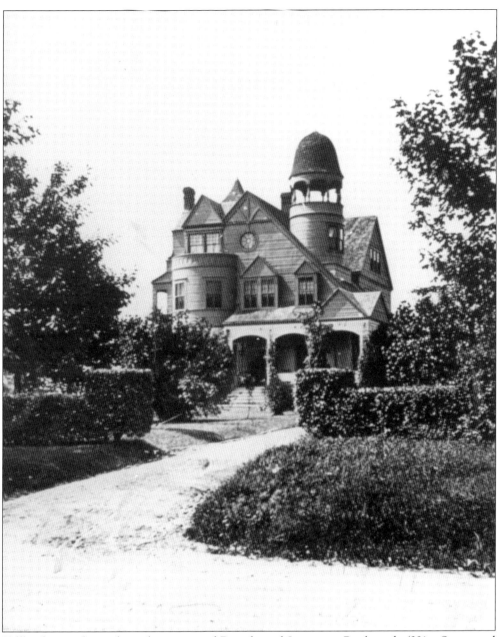

Hillbright was located on the corner of Bayside and Lawrence Boulevards (221st Street and Forty-third Avenue). The residence belonged to Frederick Storm and his wife, Annie Bell, a member of one of Bayside's oldest families. The home was built in 1893 with the main floor rooms featuring distinctly different woods. The dining room was constructed with mahogany, the living room was made with sycamore, the parlor was fitted with bird's-eye maple, and the reception hall was paneled in oak. As Storm was part owner of the famous Straiton and Storm Cigar Manufactures, rumor had it that the White Owl brand cigar got its name after an owl flew into Storm's bedroom window. The front tower is reminiscent of a cigar similar to the hand-rolled cigars made by Storm's factory. Hillbright was destroyed by fire that was reportedly started with a furnace spark on November 15, 1931.

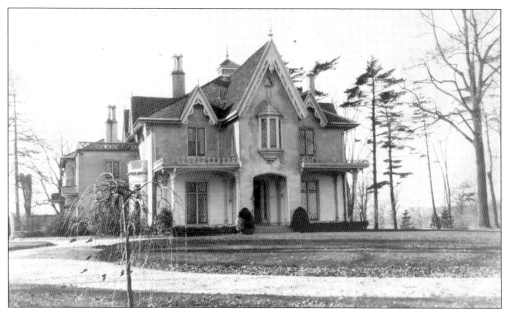

Louis S. Harway was the owner of a dyewood factory in nearby College Point. His estate, the Willows, was located at the intersection of Bell Avenue and Twenty-fourth Avenue. Harway's daughter-in-law Gertrude C. Conat Harway sold the property to the Bayview Operating Company of Manhattan. In 1926, they auctioned off 106 lots and nine waterfront parcels for $263,500. The residential area is known as Bayside Gables.

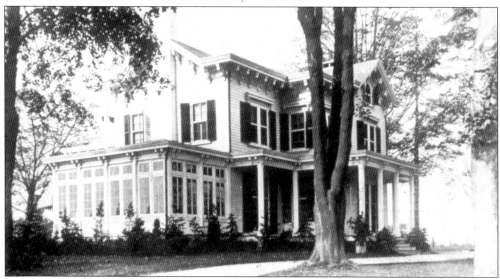

This 15-room mansion once belonged to jeweler Charles H. Conant. It was used by several community groups prior to its demolition by the New York City Parks Department in the early 1930s. Subsequently, the parks department gave a parcel of the Conant property to the department of education for playing fields across from Bayside High School. Gertrude was the sister of Charles Conant, and upon her marriage to John Wesely Harway (the son of Louis S.) two of Bayside's prominent families united. The couple moved into the Willows, and Gertrude's mother, Corneila Whitmore Conant, and her brother Fredrick K. Conant eventually came to live with them.

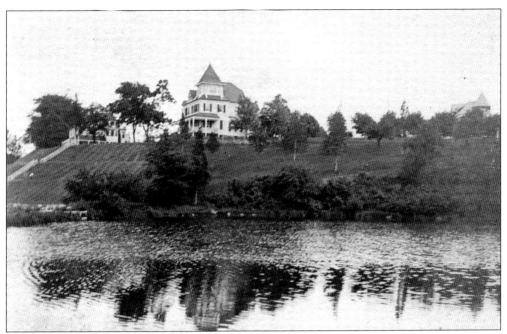

Atop the hill overlooking the Gold Fish Pond (Golden Pond) sat the Henry W. Medicus House, as seen in this photograph from 1902. H. W. Medicus was the owner of the local amateur baseball team and was also the treasurer of the Brooklyn National League Baseball Club, officially named the Bridegrooms but nicknamed the "(Trolley) Dodgers."

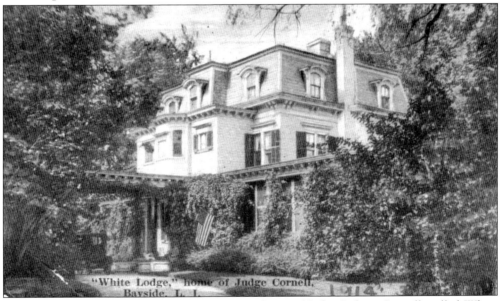

This postcard from 1914 shows the summer residence of Judge Robert Cornell, called White Lodge. The 14-room mansion was located on Little Bayside Road (near Twenty-sixth Avenue) and 209th and 210th Streets just west of Bell Avenue. Dr. Palvel J. Flagg came into possession of the Cornell property sometime after 1914, as records indicate Flagg's estate (including White Lodge) were part of a larger parcel of land that was subdivided and sold through public auction in 1925.

Affectionately known as "Mr. Bayside," producer John Golden (1874–1955) purchased this 17-acre estate from actress Pearl White in 1920 and lived in Bayside with his wife, Margaret, for more than a quarter of a century. They opened their doors to the community by sponsoring Easter egg hunts on the great lawn, creating baseball diamonds for the children, allowing caddies from the many golf courses in Bayside to practice on the estate, and freely permitting afternoon strollers to

walk the grounds. Upon his death in 1955, Golden bequeathed the estate to the City of New York for use as a park. It was officially dedicated on October 18, 1965. Although the mansion, which was located at the east end of the park, was razed after Golden's death, the parks department installed tennis courts, picnic areas, a parking lot, restored the pond, and planted additional trees, shrubs, and foliage along paths that connect directly to adjoining Crocheron Park.

This house belonged to John J. and Marie Bechamps Dwyer, owners of the florist shop on Bell and Ashburton Avenues (Thirty-ninth Avenue). Two of their three children pose out front on Fifth Street (217th Street).

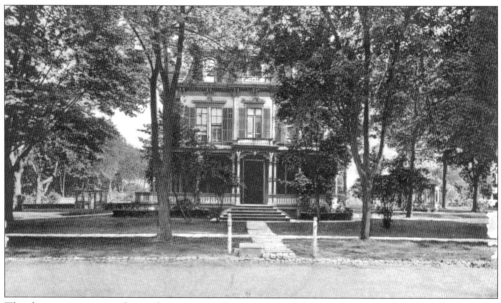

This home was situated on a large piece of property and featured two gazebos that flanked the home. Located on Lawrence Boulevard (Forty-third Avenue) and Waldo Avenue (216th Street), the house was built by J. T. Knight, a local businessman.

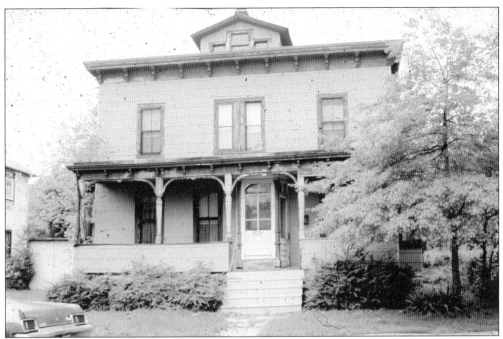

This Victorian home on Fifth Street (217th Street) and Lawrence Boulevard (Forty-third Avenue) belonged to the swimming champion Frank Eugen Dalton. It was demolished in 1981.

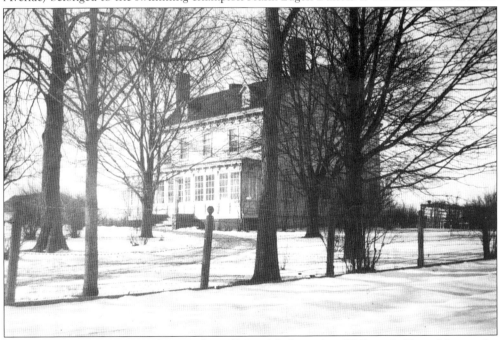

This 1860 farmhouse, located on Rocky Hill Road, belonged to William L. Titus. He was the generous citizen who donated a piece of his property so that a one-room schoolhouse could be built for the children of Bayside. After 1873, the homestead was occupied by George Bouse, and by the 1890s, the Bayside Land Association owned the property. (Courtesy of the Queens Borough Public Library, Long Island Division, Eugene Armbruster Photographs.)

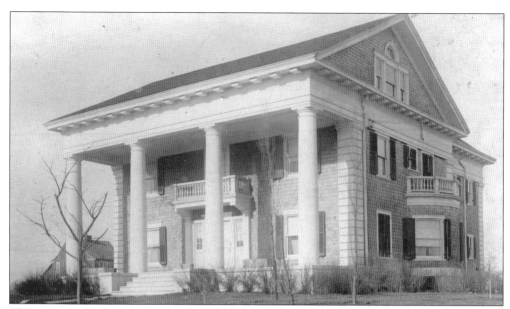

The attorney H. Stewart McKnight was the publisher of the *Bayside Review*, the town's first, but short-lived, newspaper, which he started in 1892. Three years later, the paper consolidated with the *Great Neck League* under a new name, the *North Shore Review*. As one of five brothers, McKnight was part owner of the McKnight Realty Company that greatly contributed to the development of Bayside. His home, shown here, was located at 206th Street and Forty-second Avenue. By the second decade of the 20th century, McKnight relocated to Great Neck and served as the Nassau County attorney.

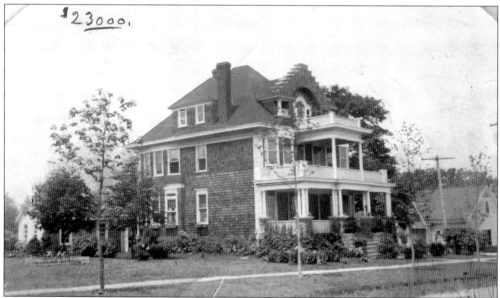

The James Blackwell property was once part of the Mickel estate, Bay Lawn, and extended from Bell Avenue to Little Neck Bay and from Crocheron Avenue (Thirty-fifth Avenue) to Ashburton Avenue (Thirty-ninth Avenue). After 1926, the property was subdivided for the construction of large single-family homes. This photograph shows an asking price of $23,000 for the home in 1926 by the Dayton Real Estate Company.

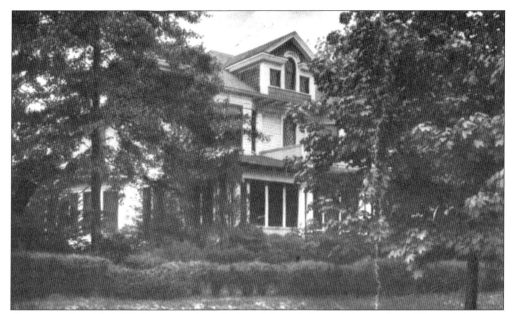

Choreographer Ned Wayburn purchased this Colonial Revival home from Norris Mason in 1918. It was located on Waldo Avenue (Twenty-sixth Street) in the area known as Bay Side Park, the former site of the George Bradish estate. The same year Wayburn moved to Bayside, he joined the Bayside Yacht Club.

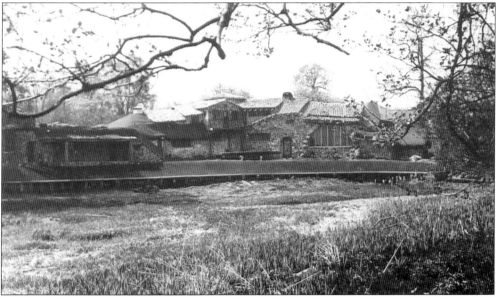

Basque Casa was the residence of the artist Rolf Armstrong. It was situated on a large parcel of the Harway estate, the Willows, in what is now Bay Terrace. Inspired by a castle he saw while in the Pyrenees, Armstrong constructed a home that reinterpreted his experience overseas. Completed in 1931, the house overlooked the bay with several boats docked outside his front door in what he referred to as Armstrong's Inlet. Several years later, Armstrong moved to Manhattan and rented Basque Casa to radio personality Nancy Craig. When Armstrong finally sold the house in the 1950s for a fraction of what it originally cost to build, he never returned to Bayside.

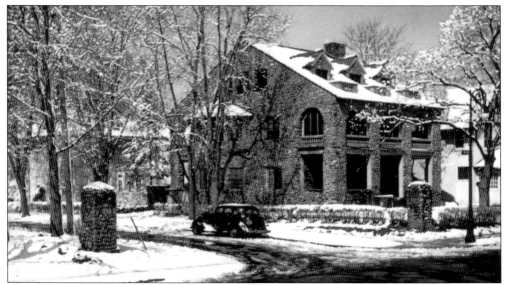

In 2004, the New York City Landmarks Preservation Commission designated the Cobblestone House, located at 35–34 Bell Boulevard, a landmark. Built in 1906, it features both the Colonial Revival and arts and crafts styles and incorporates cobblestones that are irregularly sized and shaped. Although the architect is unknown, the property was part of the 100 acres that was purchased by Bell-Court Land Development from the Bell family. The original owner of the house was Elizabeth A. Adams, who paid an estimated $10,000 for the construction of the house.

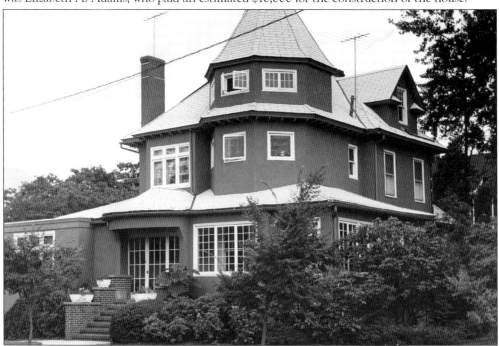

This Queen Anne–style home of James John "Gentleman Jim" Corbett and his wife Vera is situated at 221–204 Edgewater Avenue (Corbett Road and 221st Street). Upon Corbett's death in 1933, it was revealed that the original deed to the house was solely in his wife's name. It remains a private residence today.

Four

RECREATION

During the latter part of the 19th century, Bayside evolved into a recreational destination for day-trippers as well as extended vacationers taking up summer residences in lavish mansions overlooking Little Neck Bay. While many nonresidents flocked to the area, sporting activities for Baysiders did not end with bathing and clamming. Sailing enthusiasts founded the Bayside Yacht Club in 1902, and the Bayside Tennis Club was established soon after. Two semiprofessional baseball teams called Bayside home, and the town had no fewer than four golf courses for residents and visitors to enjoy.

For a small town, there was a lot to do. Organized activities were sponsored by local clubs, hay rides and sewing circles were arranged by church groups, and more cerebral events and celebratory dinners were held at Literary Hall. Winters in Bayside were just as coveted, especially by the children, as the hilly landscape lent itself to exhilarating sledding sessions, while skaters had fun on the ice at Golden Pond, Oakland Lake, and Alley Pond.

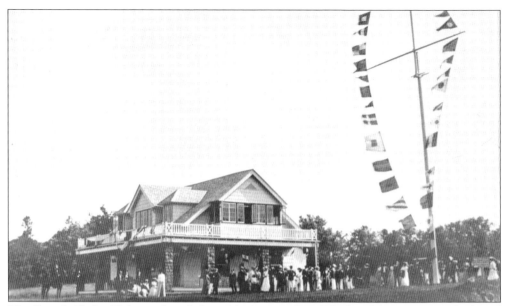

The Bayside Yacht Club was founded on July 9, 1902. By 1903, the club incorporated, elected officers, drew up a set of bylaws, and had a roster of 70 members. In the 1920s, the club boasted over 230 members. Sailing and motorboat races took place throughout the season, with other social events, including informal dances, bridge tournaments, clambakes, holiday and gala parties, wedding receptions, as well as smokers (which were given once a month for men only). In 1993, the Bayside Yacht Club filed for Chapter 11 bankruptcy due to low membership and a high operating budget. The property was sold to the Grace Presbyterian Korean Church in 1994 for $1.45 million.

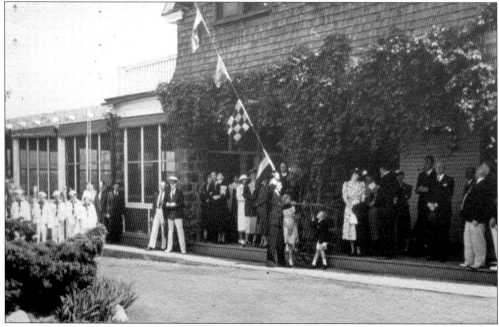

This photograph from about 1934 features the flag-raising ceremony at the season's opening-day celebrations at the Bayside Yacht Club.

The Belleclaire Country Club was situated on what was previously the James Cain farm. Cain purchased 117 acres in 1852, and the property stayed in the family until his son James W. Cain II died in 1917. The farm was purchased by the owners of the Belleclaire Hotel in Manhattan and was converted into a golf course. Cain's home, which was located near Bell Avenue by Rocky Hill Road (Forty-eighth Avenue) at the present entrance to Bayside Hills, served as the clubhouse. The property was eventually sold in the 1930s to homebuilders Gross Morton Company, which built the Bayside Hills development. The original farmhouse was torn down in 1936.

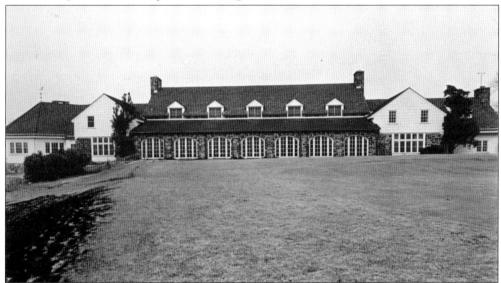

The Oakland Golf Club was organized by John H. Taylor, the son of a horticulturist, in 1896. Taylor leased 111 acres of his Oaks estate to the club and became its first president. Membership to the club was exclusive and included such prominent New Yorkers as H. P. du Pont, Charles C. Goodrich, Samuel Kress, Bernard Baruch, and Charles Schwab. In 1952, the club became a public course and was sold to Pickman and Son Realtors that same year. By the 1960s, the property was bought by the City of New York. It is now the present site of Queensborough Community College, Benjamin Cardozo High School, and P.S. 203.

Originally called the Clearview Golf and Yacht Club, the 103-acre course was founded in 1925 and designed by famed landscape architect William Tucker. In 1931, the club was sold to the City of New York for $940,000. Redesign of the course and erection of new club facilities occurred between 1935 and 1940. In 1957, the Triborough Bridge and Tunnel Authority acquired property on the eastern side of the club for the construction of the Clearview Expressway.

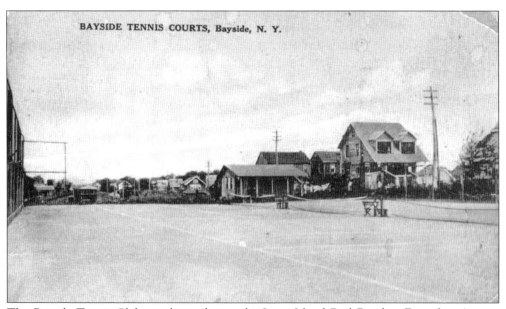

The Bayside Tennis Club was located near the Long Island Rail Road at Forty-first Avenue with the clubhouse situated at Seventh Street (219th Street). The eight-court club was formed by the Dunkerton, Sieverman, and Roberts families, all of whom were tennis enthusiasts and neighbors. The club rented the property from the Long Island Rail Road for a nominal yearly fee. Some years after forming, the club moved to its present location at 32–28 214th Place across from P.S. 41, and its name changed to the North Shore Tennis Club.

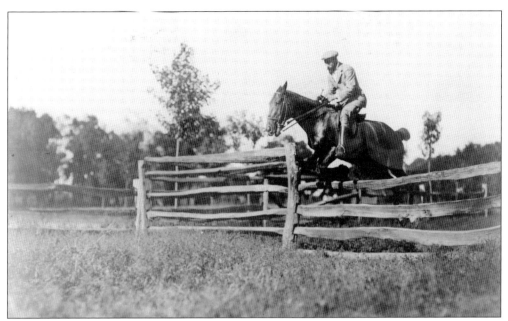

Horse racing and jumping were favorite pastimes of Bayside's elite. The Bayside Horse Show Association held annual exhibitions, beginning in 1902 with G. Howland Leavitt presiding as lead judge. In this photograph, Kenneth Caswell, a friend of the Bell family, practices his jumps on their property around 1910. (Courtesy of the Queens Borough Public Library, Long Island Division, Illustrations-Bayside.)

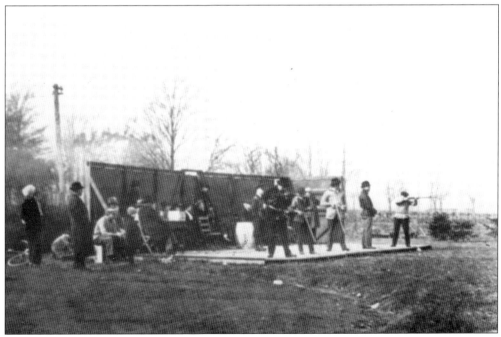

An annual event at the Bayside Yacht Club was the trapshooting competition. Traditionally held in February, the event featured neighboring clubs participating and competing for the Du Pont Trophy, as seen in this photograph from 1914.

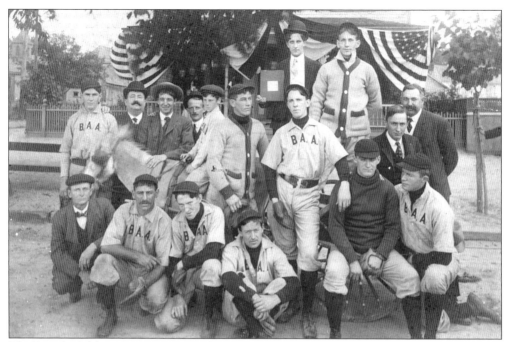

The Bayside Athletic Association was founded around 1900 and existed for only about a decade. The team played on a ball field between 215th and 216th Streets by Northern Boulevard. This photograph dates from 1907.

From left to right, members of the 1908 Bayside Athletic Club baseball team are (first row) Harry Easton, James Dywer, and J. Hope; (second row) Charles Easton, ? Corcoran, James Dayton, unidentified, and ? Johnson; (third row) ? Foster, Herman Anderson, and ? Robertson.

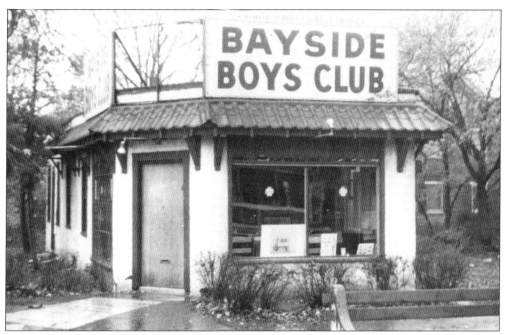

The Bayside Boys Club was affiliated with the national organization Boys Club of America. The small clubhouse in this photograph was replaced with a much larger building at the same site on Thirty-fifth Avenue east of Bell Boulevard. When the club developed financial difficulties, the YMCA took over the facility in 1979.

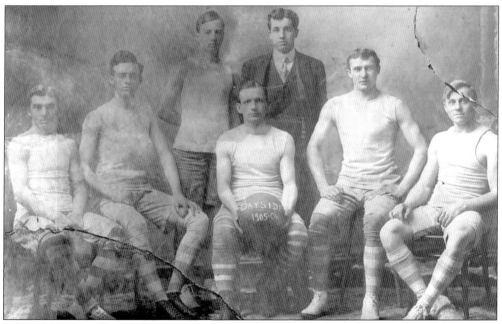

Like many towns, Bayside became enamored with the new sport of basketball and had its own team, as seen in this photograph from 1906. Devised by James Naismith in 1891 while working for the YMCA in Springfield, Massachusetts, the sport originally had 13 rules, one of which was the time limit: two 15-minute halves, with a five minute rest between them.

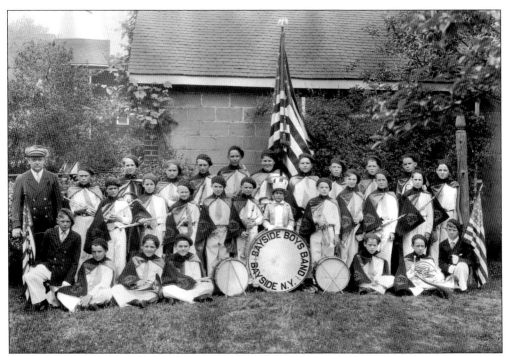

The Bayside Boys Band was founded by realtor J. Wilson Dayton in 1930 and was sponsored by the now-defunct Bayside Lions Club. The band performed locally as an ensemble group on stage and included a performance at Cohen's Theatre on Bell Avenue. It also participated in parades as a marching band and appeared in competitions throughout New York.

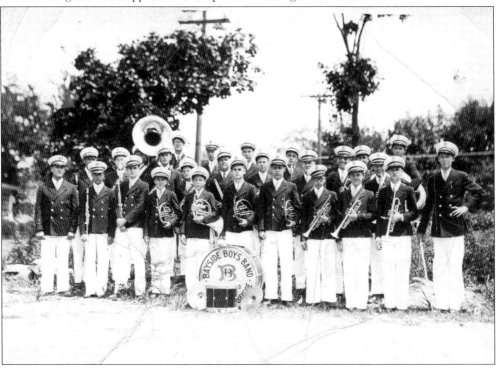

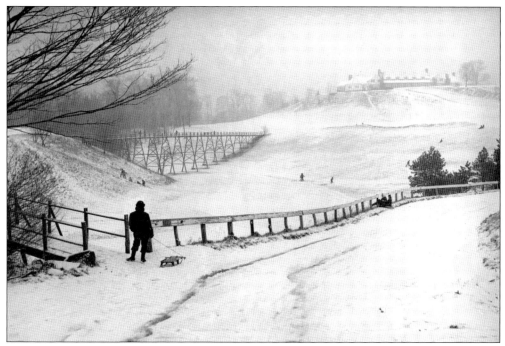

This sledder takes advantage of the hills at Oakland Golf Course in the winter of 1950. Although sledding was just as good on this golf course as it was at Crocheron Park, it was less populated by winter sports enthusiasts since it was further out of town.

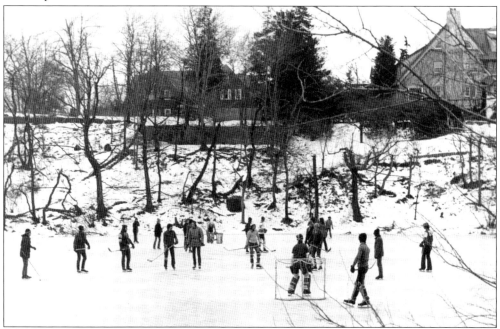

Although forbidden by the parks department in more recent decades, informal ice hockey games were always a popular winter sport on the pond in Crocheron Park, as seen in this photograph from 1967. Since the pond sits low like a basin, skating was usually pleasant, as cold winds were blocked by the surrounding steep hills.

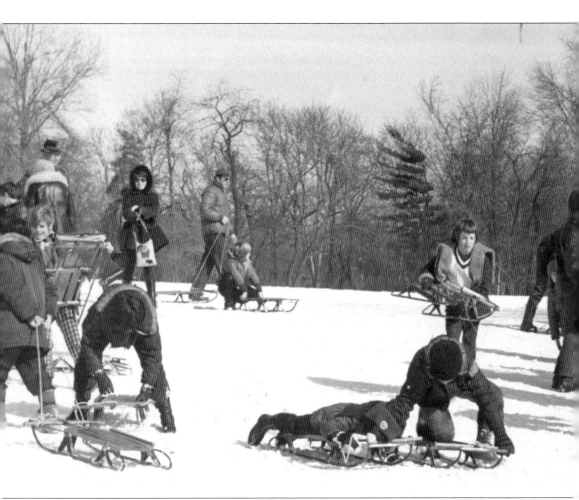

Crocheron Park has always served as the choice location in Bayside for sledding, as seen in this photograph from 1967. Before the construction of the Cross Island Parkway in the late 1930s, some fearless sledders began their journeys at the uppermost point of the park by Crocheron

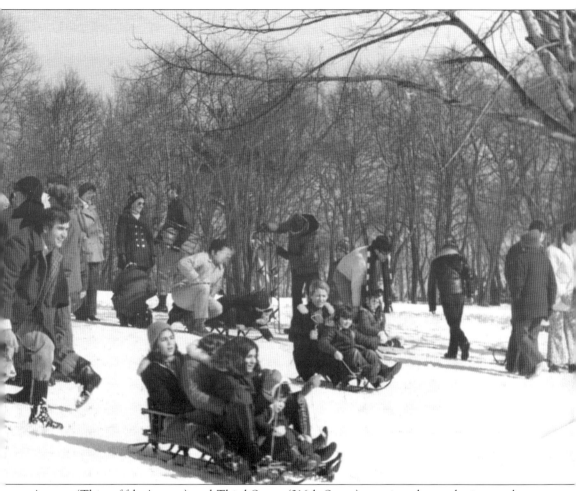

Avenue (Thirty-fifth Avenue) and Third Street (216th Street), continued over the ice on the pond, and out over the frozen water of Little Neck Bay.

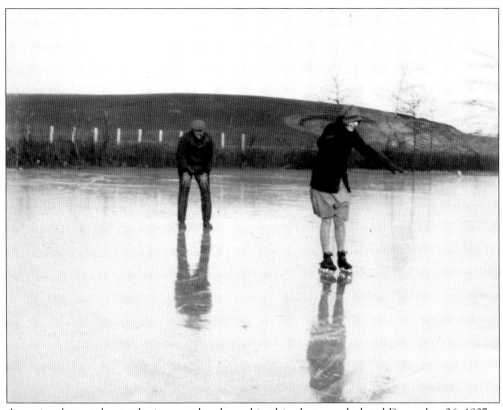

A novice skater takes to the ice on a local pond in this photograph dated December 26, 1927.

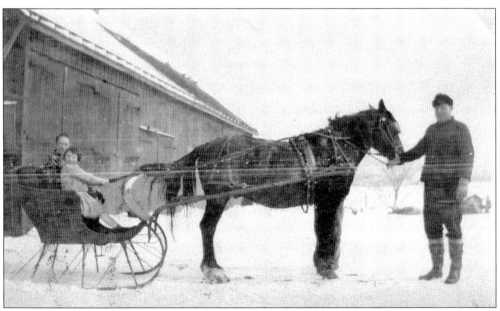

This early-20th-century photograph was taken on the local Jagnow family farm. When not used for farming chores, horses contributed to winter fun by pulling sleighs.

Five

LITTLE NECK BAY

Some maps dating as early as 1632 identify the water off Bayside as Garreston's Bay or Matagarreton's Bay. In all likelihood, the cove leading to the bay was named for Mathew Garretson, a Dutch settler who established a small colony in the area. The Matinecock tribe, however, called the bay Menhaden-Ock, which translates as "place of fish." It is said that European settlers mispronounced the name, calling it Madnan's Neck, and the nearby town of Great Neck evolved from that name. Ultimately the name Little Neck Bay was derived from the geographical shape of the small peninsula jutting out into the bay.

Regardless of what the bay has been called, it has always been an integral part of the community. From the earliest times, it served as a plentiful source of food for the Matinecocks, and the shells found along the shore were used to make currency called wampum. Bead wampum was ground and polished and then bored through with a small hand drill. White wampum could be made from a variety of shells, but the more desirable and rare violet wampum came from the purple portion of the quahog clam found in the area.

Later during the 19th century, clamming in Little Neck Bay provided a livelihood for many, and the recreational aspect of the bay was discovered as well. While the shoreline is fairly rocky, there were points along the bay that served as small beaches, and bathers also enjoyed swimming from floats moored offshore. By the dawn of the 20th century, the bay was highly touted in real estate advertisements and auctions for both its scenic quality and recreational value.

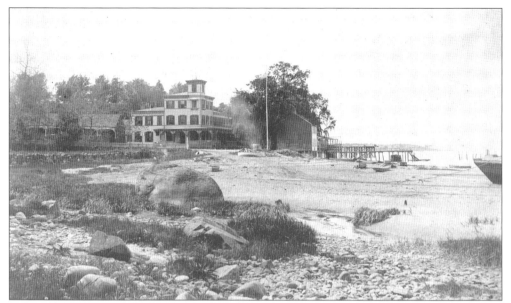

Originally called Bayside House, the hotel's name was promptly changed to Crocheron House by Joseph Crocheron when he took possession of the property in 1865. He was a descendent of John Crocheron, a farmer who first settled in the area sometime before 1695. Other members of the Crocheron family include Henry Crocheron, a congressman from 1815 to 1817; Jacob Crocheron, a congressman from 1829 to 1831; and Nicholas Crocheron, a member of the 1854 New York State Assembly.

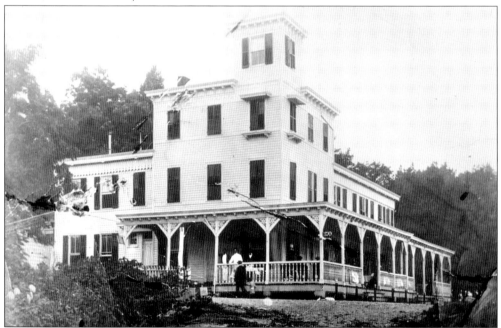

Crocheron House was a favorite resort destination frequented by celebrities and politicians of the 19th century. The hotel was destroyed by fire at the beginning of the 20th century, and the property remained unused for nearly 20 years. In 1924, the City of New York purchased the land as well as an additional 45 acres next to it. In 1936, the area was officially named Crocheron Park.

This postcard from 1908 features Garrison's Inn. Owned by Anthony Miller, the hotel opened in 1890 and was located at the northern end of Bell Boulevard near the entrance to Fort Totten. Like its neighbor Crocheron House, Garrison's Inn was a favorite resort destination for both locals and tourists.

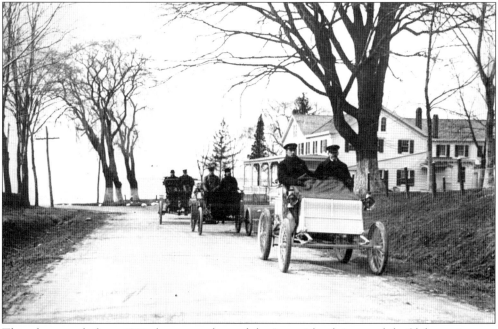

This photograph from 1902 shows members of the Long Island Automobile Club starting out on their first 100-mile endurance run, with Garrison's Inn in the background. The hotel's name may reference the early settler Mathew Garretson. It is more likely, however, that the name was derived from the garrison at nearby Fort Totten. Soon after Prohibition, the inn was acquired by a local boating organization, the New York Canoe Club, which leased the building and dock until it ceased operations in 1930.

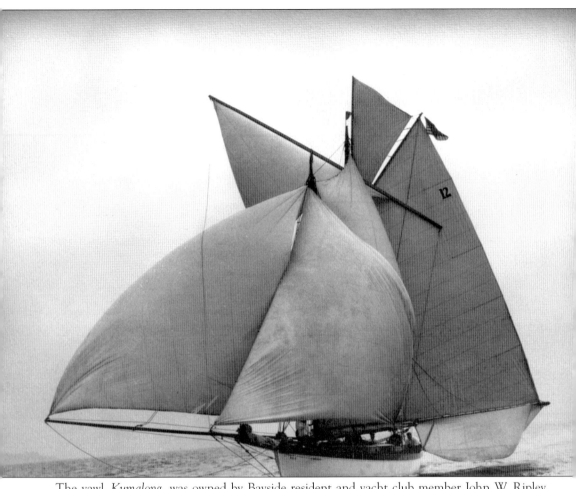

The yawl, *Kumalong,* was owned by Bayside resident and yacht club member John W. Ripley. The photograph was taken during the Bayside-Block Island Auxiliary Handicap race of 1923, which was sponsored by the yacht club. According to the club's logbooks, *Kumalong* did not place that year.

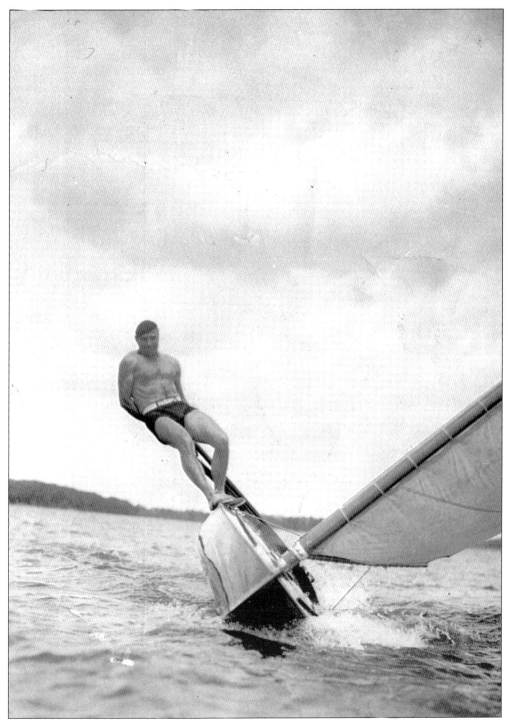

The artist Rolf Armstrong shows off his sailing technique in this photograph taken on Little Neck Bay in 1934. Armstrong was an accomplished sailor, having won the American Canoe Sailing Championship in Thousand Islands, New York, in both 1934 and 1935, with his favorite canoe, the *Mannikin*.

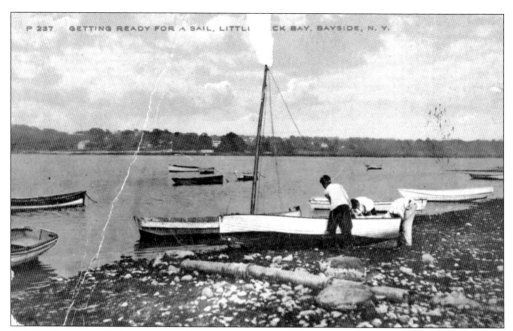

It is evident how rocky the shoreline of Little Neck Bay is in this postcard from about 1905. While many large estates lined the bay and boasted riparian rights, the public could also access the water from several points along the shore.

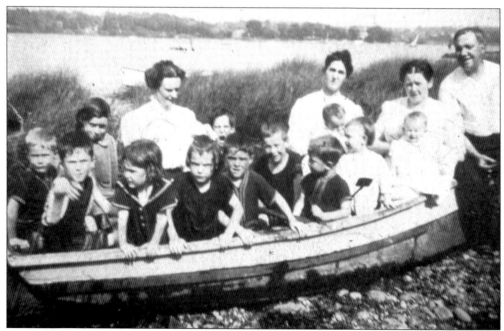

Members of the Bergen and Hickey families pose in a boat along Little Neck Bay in this photograph from 1910. Many Baysiders not only learned to swim in the bay, but their sailing skills were also honed there.

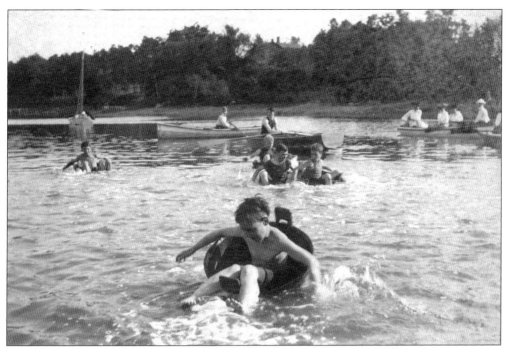

A popular activity with the younger boys of Bayside was tub racing in the bay. This photograph from about 1915 shows an unidentified boy in the foreground with a clear lead. Spectators watched the event from their boats, which also served as the starting line for the race.

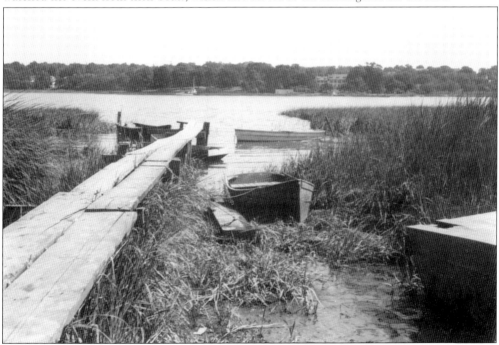

Many makeshift piers, such as the one seen in this photograph, were built along the shore of the bay prior to the construction of the Cross Island Parkway. They allowed for easier access to the water, boats, and floats.

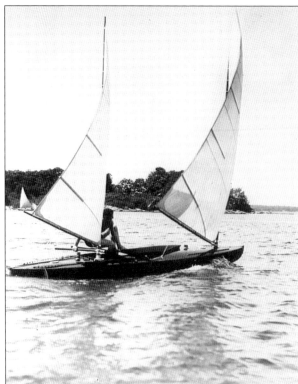

This 1934 photograph shows a common sight on Little Neck Bay where small sailboats and skiffs headed out from the yacht club's marina (many of which were built in the backyards and garages of Bayside during the off season). As a result of the Cross Island Parkway construction, the public had to access the water via a bridge that led to a pier and launching facility built by the city at Twenty-eighth Avenue. It replaced the Bayside Yacht Club's marina when it lost its riparian rights due to the parkway.

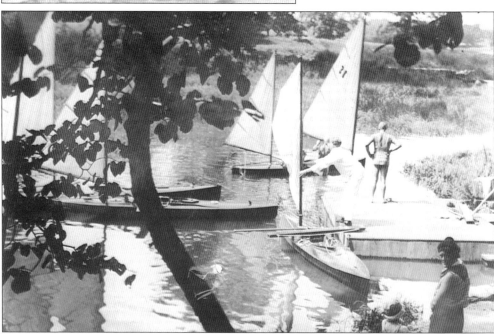

As seen in this photograph from 1933, artist Rolf Armstrong referred to the creek that flowed from Little Neck Bay to his dock as Armstrong's Inlet. Large enough to accommodate the small fleet of sailboats he maintained, the creek dried out after construction of the Cross Island Parkway cut off access to the bay.

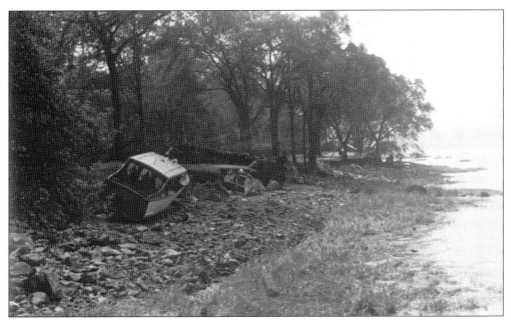

Referred to as the "Long Island Express," the hurricane hit shore at about 3:00 p.m. just a few hours before high tide on September 21, 1938. The magnitude of the storm and the damage it caused were unprecedented in this area and made it the most costly hurricane at that time.

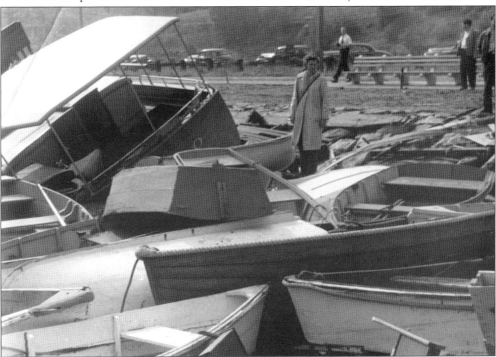

Known as the Great Atlantic Hurricane, this storm reached the shores of Long Island on September 15, 1944, devastating much of the coast, including Little Neck Bay. In this photograph, a woman stands amid the jumble of boats inspecting the damage, while cars line up along the Cross Island Parkway for a better view.

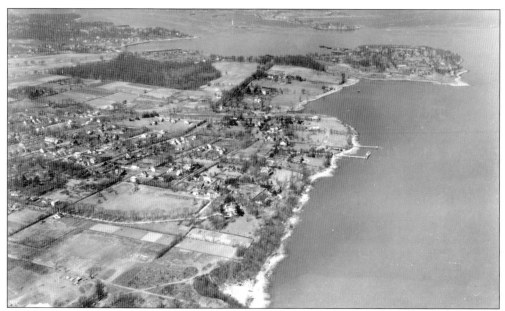

There was no greater impact on Bayside and its connection with Little Neck Bay than the construction of the Cross Island Parkway. Pedestrian access was effectively cut off from the bay while homeowners along the shore (as well as the yacht club) lost their coveted views and riparian rights. Initiated by New York City's parks commissioner Robert Moses, construction of the parkway began in 1934 with sand that was dredged out of Ambrose Channel, towed up the East River, and pumped onto the shoreline from Willets Point to just past Northern Boulevard. The parkway was officially dedicated in 1940 and included a bridge extending over the highway at Twenty-eighth Avenue to a pier and launching facility that replaced one built by the Bayside Yacht Club.

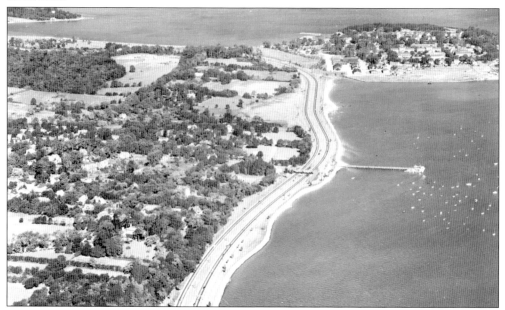

Six

FAMOUS RESIDENTS AND PILLARS OF THE COMMUNITY

The town of Bayside is comprised of more than just its scenic beauty and ideal location. Its residents make up its unique quality and give the town a sense of community. Throughout its history, Bayside has had, as it still does today, the advantage of its citizens. Volunteerism, activism, and community spirit are all characteristics of Bayside's residents. Leaders with forethought and civic mindedness, such as Joseph Brown, the founder of the Bayside Historical Society, and John Golden, who bequeathed his property to the City of New York for all to enjoy, set the standard for which everyone should strive.

This chapter features some important Baysiders. While it is by no means a complete account, it is indicative of the diversity of these individuals. Some were famous, and some were philanthropic, but all of these Baysiders enriched the lives of others. People such as Frederick Storm, Elizabeth Boyce Lawrence, and William L. Titus gave their time and property for the benefit of the community. Others, including the boxer James John "Gentleman Jim" Corbett, were famous before settling in Bayside. Olympic gold medallist Aeriwentha "Mae" Faggs Starr was the product of this community and earned her fame beyond Bayside's borders. Artist Rolf Armstrong found Bayside to be ideal for both its recreational and inspirational value. Sculptor and father of eight, Philip Martiny, settled in the community for the same reasons many residents chose to live in the area. Bayside was able to provide the best opportunities in which to raise a family. Ultimately, it is the composition of the community's residents that makes the town successful. Baysiders can boast this unabashedly.

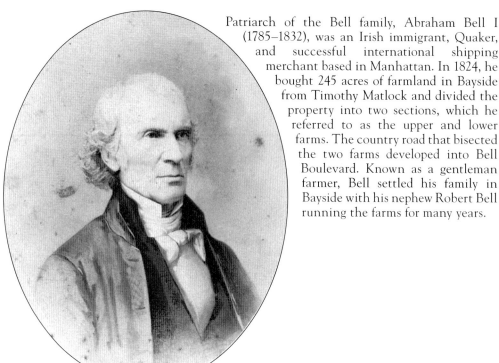

Patriarch of the Bell family, Abraham Bell I (1785–1832), was an Irish immigrant, Quaker, and successful international shipping merchant based in Manhattan. In 1824, he bought 245 acres of farmland in Bayside from Timothy Matlock and divided the property into two sections, which he referred to as the upper and lower farms. The country road that bisected the two farms developed into Bell Boulevard. Known as a gentleman farmer, Bell settled his family in Bayside with his nephew Robert Bell running the farms for many years.

Abraham Bell II (1841–1914) was the son of Thomas Bell (1816–1864) and the grandson of Abraham Bell I. Abraham II was charged with the upper farm upon his father's death, and in 1870, he married Melissa Chambers (died 1927). They moved into their new home on Bell and Warburton Avenues (Thirty-eighth Avenue) that same year. Active in community affairs, Abraham II and other local farmers unsuccessfully petitioned against the increased tax assessment of their property, as it was no longer deemed farmland by the early 1890s. At the beginning of the 20th century almost all of the Bell land was sold to developers.

Frederick Storm (1844–1935) emigrated with his family from France in the late 1840s. His brother George Storm (1838–1904) established a cigar business and bought property in Bayside. While Frederick was visiting his brother, he met Annie Lawrence Bell (1847–1937), the daughter of Thomas C. and Eliza Hough Bell. The couple married in 1876 and Frederick joined his brother in the cigar-making business known for its White Owl brand. Fredrick was a highly successful businessman, entrepreneur, and politician, who became a delegate to the New York State convention in 1894, was elected to the state assembly in 1896, and served as a U.S. representative in the 57th Congress from 1901 to 1903. He may best be remembered as the founder of the Bayside National Bank, which was established in 1903. Frederick and his wife were two of Bayside's most prominent citizens, having donated land and funds for community causes, including the Bayside Women's Club and Literary Hall.

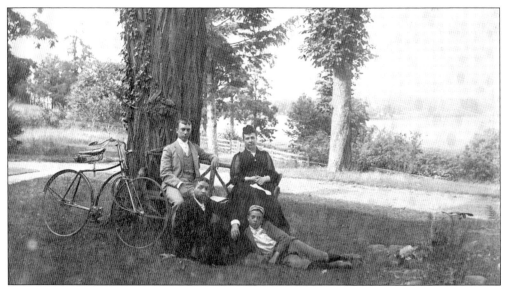

Members of two politically active, socially connected Bayside families gathered under a tree for this 1891 photograph. Sitting on the grass are George Benjamin Mickel, the son of former New York City mayor Andrew H. Mickel, and Effingham Lawrence Jr. (right). L. Lee and Janet C. Mickel Lawrence (right) are seated on the bench. (Courtesy of the Queens Borough Public Library, Long Island Division, Illustrations-Bayside.)

Frank Eugen Dalton was the 1896 amateur swimming champion and founder of the Dalton method and the Dalton Swimming School in Manhattan. He lived with his wife and two sons, Louis and Frank Jr., at 43–14 217th Street. Also a member of the New York Life Saving Corps, Dalton wrote an instructional book titled *Swimming Scientifically Taught; A Practical Manual for Young and Old* that was published in 1912 by Funk and Wagnall Company.

Originally from Charleston, South Carolina, Elizabeth Boyce Lawrence (1835–1894) stood apart from her Bayside contemporaries as the southern-born wife of Col. Fredrick Newbold Lawrence (1834–1916). Elizabeth had three daughters and was instrumental in establishing All Saints Episcopal Church on Montauk Avenue and Second Street (Fortieth Avenue and 215th Street), as she donated the property for the church in 1891. Three years later, she died of pneumonia at the age of 59 and was buried at the Lawrence Family Cemetery.

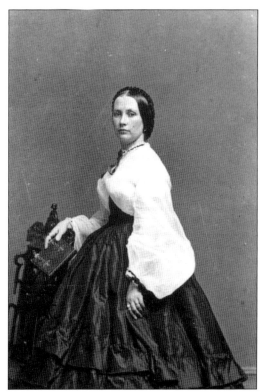

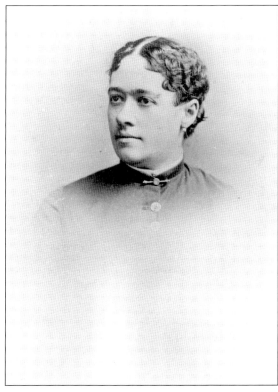

This 1870 photograph shows Anna P. Willets (1850–1917) in her uniform from the Bayside Quaker School that was founded by Abraham Bell II near Crocheron Avenue (Thirty-fifth Avenue) and 210th Street. Willets could trace her ancestry back to Plymouth Colony. She was the daughter of Thomas S. Willets and Rebecca Fox Leggett of Flushing, New York, and a close relative of the Bayside Willets family. (Courtesy of the Queens Borough Public Library, Long Island Division, Portraits Collection.)

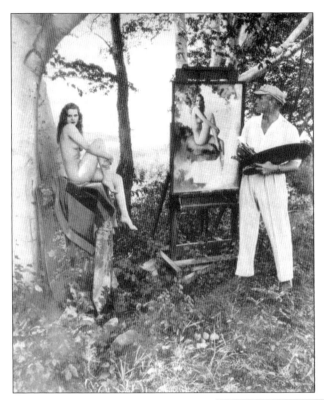

Artist Rolf Armstrong (1889–1960) is known as the "Father of the American Pin-Up Girl." His beautiful women graced movie magazines, advertisements, and calendars in the 1930s, 1940s, and 1950s. Immensely successful as a commercial artist, Armstrong had the opportunity to fully enjoy the recreational aspects of Bayside and became an avid sailor with membership to the Bayside Yacht Club.

Scantily clad interpretive dancer Rosita Royce (1918–1954) moved to 33–23 206th Street with her parents upon her extended engagement in the Crystal Place at the 1939 New York World's Fair. Using doves for props, Royce performed a striptease at the fair eight times a day during the week and 10 times on Sundays and holidays. In 1941, *Time* magazine reported that Royce volunteered to help the military train pigeons for defense purposes.

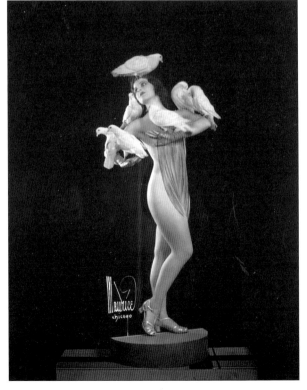

G. Waldo Smith (1831–1913) was elected the first commodore of the Bayside Yacht Club in 1902. His early experience at sea was as a cabin boy serving on his father's clipper ship. When Smith was in his 20s, he and his brothers opened a grocery store at 42nd Street and Eighth Avenue in Manhattan and expanded into the whole flour and grain business. Smith retired to Bayside as a millionaire and bought the former George Bradish estate encompassing 110 acres. He died at the age of 82 from ptomaine poisoning after eating clams while in Cape May, New Jersey.

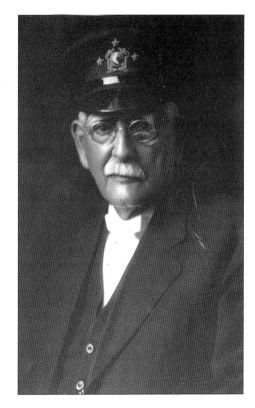

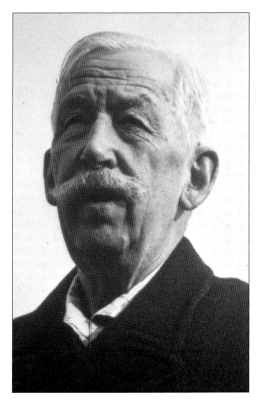

Known as the "Dean of American Yachtsmen," William Picard Stephens (1854–1946) was a legendary figure among maritime enthusiasts. He lived with his wife and two sons along Little Neck Bay. Stephens was one of the original founders of the American Canoe Association as well as the Society of Naval Architects and Marine Engineers. He was a contributing columnist for *Forest and Stream* magazine and author of numerous books, including *Canoe and Boatbuilding for Amateurs, Supplement to Small Yachts, American Yachting,* and *Traditions and Memories of American Yachting.* Stephens died at his home in Bayside at the age of 91.

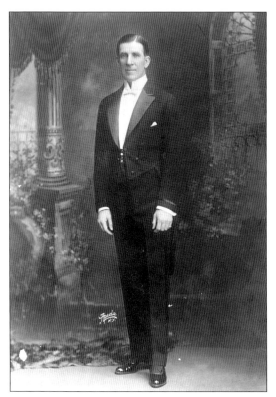

James John Corbett (1866–1933), better known as "Gentleman Jim," lived on Bayside and Third Avenues (Corbett Road and 221st Street) with his wife Vera, from 1902 until his death in 1933. He became the heavyweight boxing champion of the world in 1892, having knocked out the "Boston Strong Boy," John L. Sullivan, in 21 rounds. Corbett was also an actor and appeared in both movies and on stage. His most famous role was that of the lead in *Gentleman Jack*, a play that closely resembled his own life story.

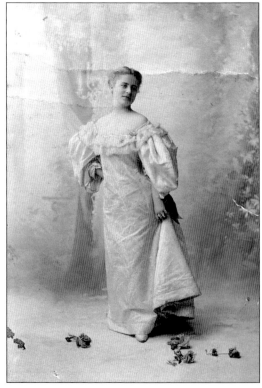

Thirteen days after heavyweight boxer Corbett divorced his first wife, Olive, in 1895, he married Vera Stanhope (died 1959). While Stanhope was the name she went by during those years, she was also known as Vera Stanley or Vera Holden, although her real name was Jessie Taylor. She and Corbett met only three months prior to their marriage in Kansas City while Corbett was on tour performing the leading role in *Gentleman Jack*. Shortly after they wed, the Corbetts settled in Bayside. She remained in their Queen Anne–style home until her death in 1959.

Three-time Olympic competitor Aeriwentha "Mae" Faggs Starr (1932–2000) grew up in Bayside and honed her skills as a sprinter at the Police Athletic League in Flushing. Later she was awarded a scholarship to attend Tennessee State University. At the age of 16, Faggs competed in the 1948 Summer Olympic Games held in London. She and her teammates took home the gold for the 100-meter relay at the 1952 Summer Olympics in Helsinki. Four years later, in 1956, she won the bronze medal in Melbourne. Faggs was elected to the U.S. Track and Field Hall of Fame in 1976. (Courtesy of Special Collections, Brown-Daniel Library, Tennessee State University.)

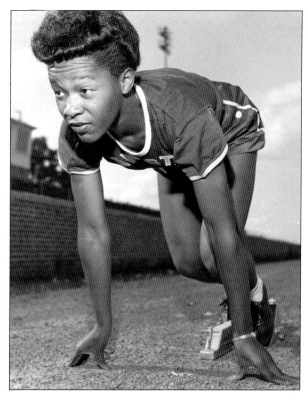

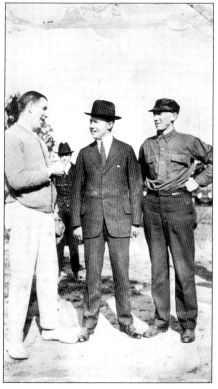

Cartoonist, reporter, and sportswriter Thomas Aloysius "Tad" Dorgan (1877–1929) (left) got his start as a teenager with a local San Francisco newspaper. By the early 1900s, Dorgan moved to New York to work for William Randolph Hearst's *New York Journal* as a sports cartoonist and later as a columnist. Dorgan is credited with creating many slang words and phrases, including "23 skidoo," "for crying out loud," "cat's meow," "as busy as a one-armed paperhanger," "dumb bell," and "drugstore cowboy," among others. Dorgan and Corbett (right) purportedly knew each other from their early years in San Francisco. They are seen in this photograph with James Dayton (middle). Dorgan lived in Bayside for several years before moving to Great Neck.

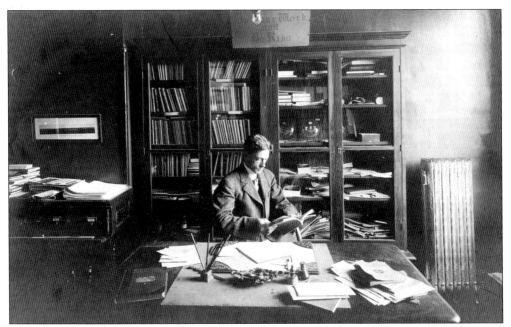

One of the earliest principals of P.S. 31 was George Dorland, seen here in his office around 1910. An avid golfer, Dorland was associated with the Van Cortland links prior to his arrival in Bayside. He was a member of the Oakland Golf Club and advocated for his male students to be employed as caddies at the club, although the Bayside School Board opposed it.

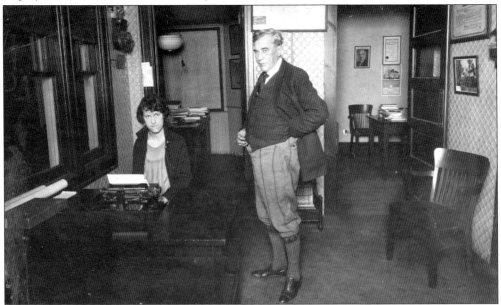

John Calvin McKnight (1868–1928) was a leading real estate developer in Bayside, having teamed up with J. Wilson Dayton to form the Dayton McKnight Real Estate Company. McKnight was also a prominent republican and worked as secretary for the New York State Republican chairman, serving under Thomas C. Platt, Charles W. Hackett, and Benjamin B. Odell Jr. McKnight lived with his wife, Mary Hendrickson, and their two children on Fifth Street (217th Street) and is seen in this photograph with Helen A. Meyer in his Bayside real estate office.

Influential theater critic Alfred J. Cohen (1861–1928) wrote under the pseudonym Alan Dale and was both legendary and feared for his reviews. In 1895, he joined William Randolph Hearst's publication, the *Journal-American,* which increased his readership substantially. Dale also was the author of several novels, including *A Marriage Below Zero, My Footlight Husband, A Moral Busybody,* and *A Girl Who Wrote.* Dale lived on Crocheron Avenue (Thirty-fifth Avenue) in Bayside. (Courtesy of the Library of Congress, Prints and Photographs Division.)

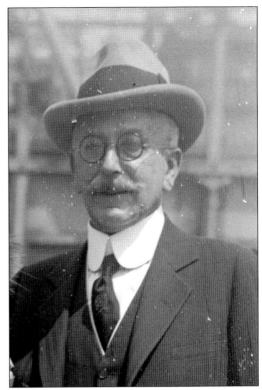

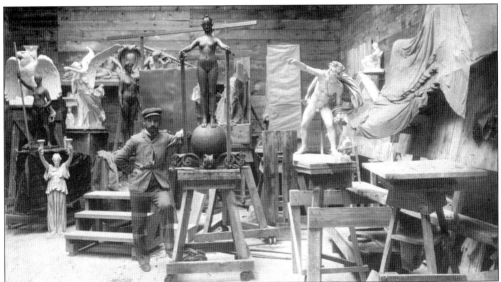

Seen here in his temporary studio at the 1893 World's Columbian Exposition, sculptor Philip Martiny (1858–1927), a native of Alsace, France, came to New York in 1878 and settled in Bayside, where he raised eight children and lived until his death at the age of 69. Working in the Beaux-Arts tradition, some of his more important works include the bronze doors of St. Bartholomew's Church in Manhattan, the Soldiers and Sailors Monument in Jersey City, and the ornamental decoration in the Great Hall at the Library of Congress in Washington, D.C. (Courtesy of the Philip Martiny papers, 1858–1973, Archives of American Art, Smithsonian Institution.)

A Bayside resident for more than 40 years, Joseph H. Brown (1892–1974) was the founder of the Bayside Historical Society. Upon retiring from Union Carbide in 1959, Brown devoted himself to his community by initiating preservation efforts at the Alley and Lawrence Family Cemetery as well as rallying community pride by rehabilitating the many garden malls along the avenues of Bayside. Stemming out of the Bayside Beautification Council, his dedication and forethought led to the formation of the historical society in 1964, and he served as the organization's president for its first 10 years. (Courtesy of Joan Wettingfeld.)

Seven

IN AND AROUND TOWN

Although Bayside began as a horticultural and farming community, much of it was transformed during the early years of the 20th century. Many landowners were forced to sell off acreage, as property taxes overwhelmed them and residential developers discovered Bayside (and all of its amenities) to be an ideal location. The combination of these factors resulted in phenomenal growth during the early 20th century.

Along with this rapid growth came the replacement after 1916 of named streets, avenues, and boulevards with a numerical system. The transition corresponded to the U.S. Postal Service establishing an office on Elise Place (Forty-first Avenue). Bayside was thus jettisoned into becoming more citylike, rather than retaining its small-town feel, with the loss of such names as Palace Boulevard (Forty-second Avenue), Lamartine Avenue (Thirty-sixth Avenue), and Christy Street (213th Street).

Neighborhoods with distinct architectural styles and characteristics sprung up around town, including Bay Side Park, Bayside Gables, Bayside Hills, Weeks Woodlands, and Bell Court. Even though Bell Avenue was the epicenter of Bayside's commercial life early on, it was not contained there. The influx of many new residents brought the need for new businesses, schools, houses of worship, cultural institutions, and improved public works.

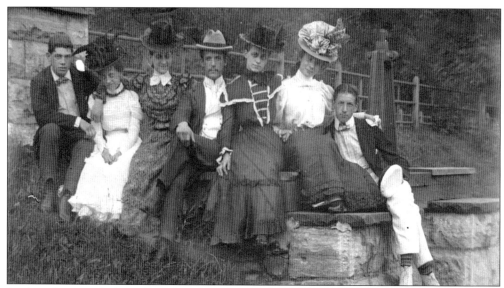

In this photograph from about 1900, a group pauses at Oakland Lake. Once known as Mill Pond after Thomas Hicks harnessed the overflow running east to Alley Creek, the lake was later called Douglas Pond. It was officially renamed Oakland Lake in 1874 when the site was purchased by the Town of Flushing. In 1934, the New York City Parks Department received the land and engaged the Works Progress Administration (WPA) to line the ravines that fed into the lake with cement. The following decade, more work was completed in an attempt to control the mosquito population; yet the results severely damaged the ecosystem. Recent decades have seen a major rehabilitation of the lake due to preservation efforts of community groups.

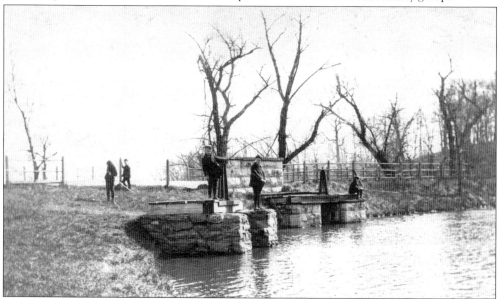

Sluice gates were constructed for Oakland Lake when the Town of Flushing purchased the area in 1874 in order to secure a municipal water source. The town built the Bayside Pumping Station and a pipeline along Northern Boulevard to deliver water to its residents in Flushing and some areas within Bayside. The lake ceased supplying water after the city of New York consolidated in 1898 and began receiving water via upstate reservoirs.

In response to community needs for a public meeting place, Baysiders rallied to raise funds for the construction of a building on donated property from John Straiton and Frederick Storm. Located on 215th Street and Forty-second Avenue, the cornerstone of Literary Hall was laid on Decoration Day in 1874. The building was used by many organizations for various purposes, yet by 1912, there were not enough funds to maintain it. Literary Hall was taken over by the Bluestone Bottling Company and was eventually demolished in the late 1920s.

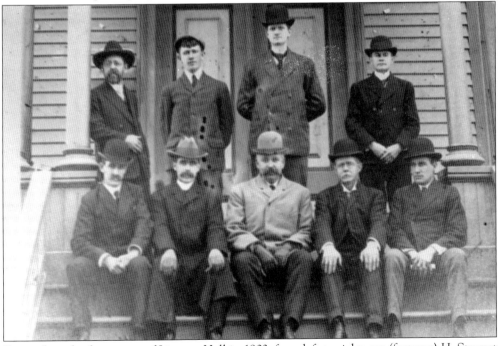

Pictured on the front steps of Literary Hall in 1903, from left to right, are (first row) H. Stewart McKnight, John Dayton Sr., Frederick A. Storm Jr., Rev. George Albert Simons, and ? Ward; (second row) A. W. Stevens, Carl D. Boyton, Frank W. Shapter Jr., and Dave Crespin.

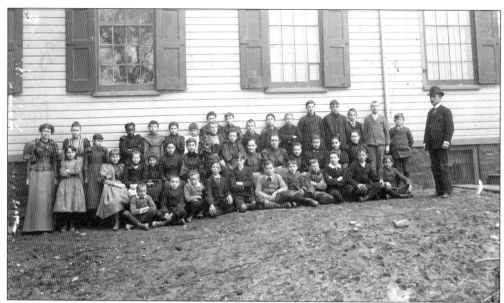

Bayside's public school served the community since its inception in 1842. The original one-room schoolhouse was erected on the William L. Titus farm at Forty-eighth Avenue and 216th Street at a cost of $360. In 1859, a two-room schoolhouse replaced the original and was relocated across the street. In 1864, the Union Free School District No. 2 of Flushing Township was established. By 1883, the school was moved again—this time near the site of present-day P.S. 31.

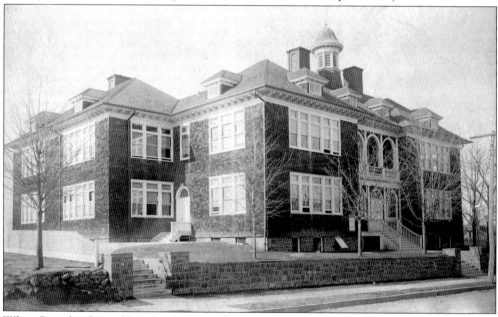

When Bayside's first public school relocated to its new location in 1883, it took another 12 years before construction of the new building was completed. As seen here, the building had four classrooms, an office, a reception room, a library, two playrooms, and a four-room apartment on the third floor for the custodian. When Bayside became part of New York City in 1898, the school was officially renamed P.S. 31. In 1939, the school was demolished and replaced with a new building. It officially opened in the fall semester of 1940.

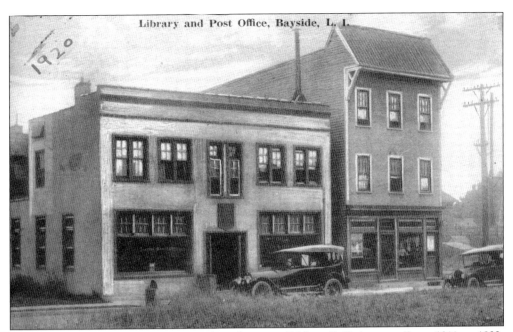

Library and Post Office, Bayside, L. I.

Bayside's earliest public library opened its doors in 1906 on Bell Avenue. From 1911 to 1932, the library was located on Elsie Place (Forty-first Avenue) near the Bayside Fire Department. In 1916, the U.S. Postal Service established an office in the building directly next to the library, as seen in this postcard from 1920.

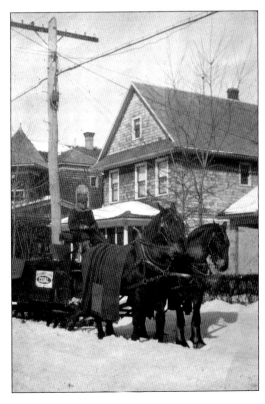

In this photograph from 1915, an employee of a local coal delivery business, Hawley and Sons, makes his rounds on Park Avenue (Forty-second Avenue) and 214th Street with his horses, Ted and Prince.

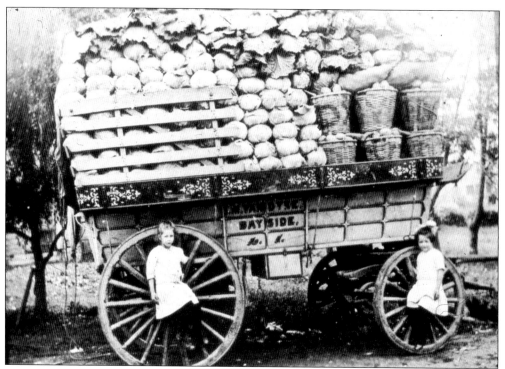

A common sight in Bayside during the 19th and early 20th centuries was wagons fully stacked with produce on their way to area markets. Known as truck farms, they produced crops that included vegetables such as corn, beets, carrots, beans, lettuce, and peas.

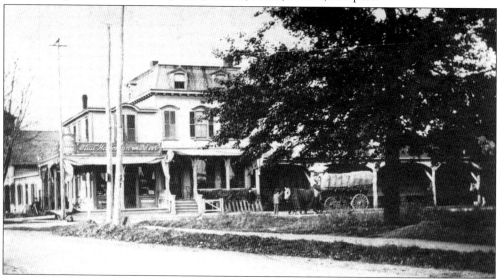

Located on the northeast corner of Bell Avenue and Broadway (Northern Boulevard) was Fred Snell's inn. Built around 1880, the Broadway Hotel was a popular rest stop for farmers bringing their produce to market. With its five carriage bays, the hotel was not only able to accommodate farmers' horses, but was also able to provide for coach horses. Snell ran a lucrative business for many decades, yet by the early 20th century, the inn was no longer financially viable, and the Broadway Hotel became a tavern.

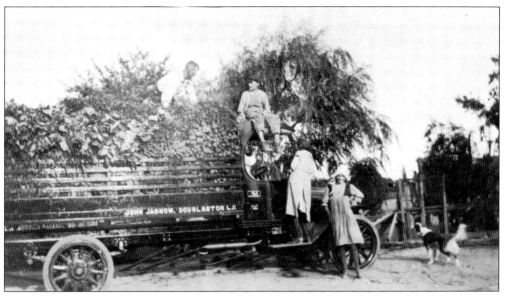

Members of the Jagnow family at their farm, which was situated on the outskirts of Bayside, are seen readying their truck for the trip to market in this photograph from about 1910.

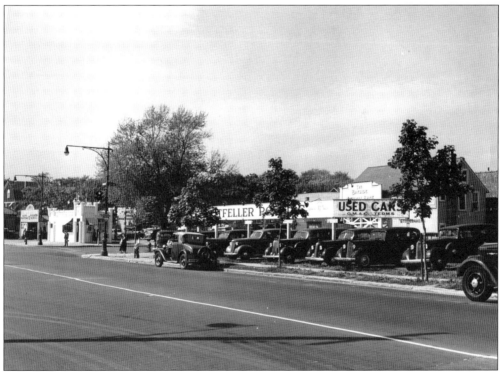

After the Broadway Hotel was razed, the site was used by a car dealership. It later became the home of the Bayside Federal Savings and Loan Association. The original White Castle restaurant, established in 1932, can be seen across the street.

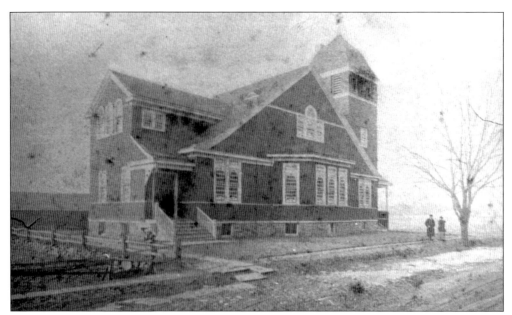

The United Methodist Church lays claim to being the first congregation to build a permanent church in Bayside. Shown in this photograph from about 1895, it was located on Palace Boulevard (Forty-second Avenue) and 214th Street. Fire destroyed the building in 1912, and a new one was erected in its place.

This postcard from about 1905 shows a house in Bay Side Park. The area was developed on the former George Bradish estate. As Bayside became a prosperous commuter suburb within easy reach of Manhattan, it ignited massive land development and home sales. Touted in advertisements as the "Eden of Long Island," Bay Side Park was developed by the North Shore Realty Company. With an array of home styles and prices on various-sized lots, the development targeted the upper-middle class.

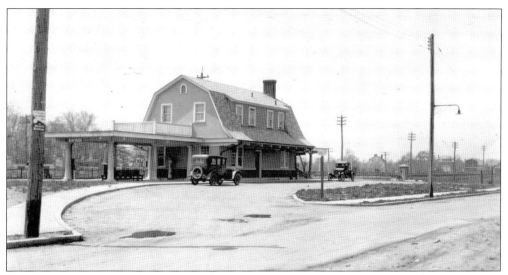

Bayside's transformation from a rural farming community into a commuter suburb started in 1866 when the North Shore Rail Road built a line from Flushing to Great Neck. By 1876, the Poppenhusen family united their competitors, consolidating several lines, including the Long Island Rail Road, the Flushing Rail Road, and the North Shore and Central Rail Road. In 1900, the Long Island Rail Road was bought by the Pennsylvania Rail Road, electric rails were installed in 1908, and direct service into Manhattan began in 1910. This photograph shows the newly built Bayside station in 1924. The station replaced the original structure and was relocated to the north side in anticipation of the project that depressed the tracks below street level in 1929.

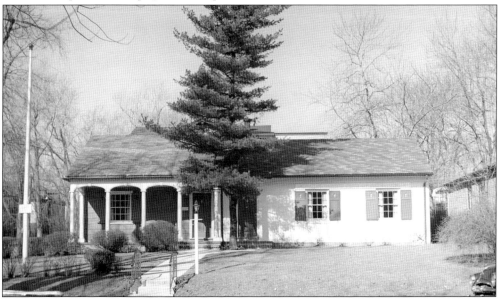

The Bayside Women's Club was founded in 1916 by a group of eight women seeking to assist the Red Cross during World War I. By 1920, the club had greatly expanded its membership and was given land by Frederick and Annie Bell Storm on Bell Avenue for the site of its new home. The meetinghouse was built for a total cost of $3,410.64. In 1925, the club purchased the adjoining lots and saw its roster swell to over 100 members. The club's headquarters remained on the boulevard for over 80 years.

Bayside Hills was developed in the late 1930s by the Gross Morton Company. It purchased Belleclaire Golf Course, leveled the hills the area was known for, and constructed single-family homes in the cape, Colonial, and Tudor styles on 40-by-100-foot lots. In 1995, the civic association of Bayside Hills merged with its neighbors to the east, a smaller development of 235 homes known as Oakland Hills.

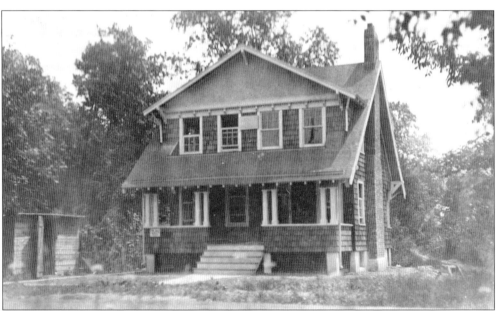

In 1904, the Rickert-Finaly Realty Company purchased the last 95 acres of the Bell farm from Abraham and Melissa Chambers Bell. The property was subdivided for single-family homes under the name Bell-Court Land Company, with an indenture of nine stipulations concerning cost, size, and character of the homes. Almost all of the homes sold within two years.

Designed by master bridge builder Othmar Ammann under the auspices of Robert Moses, construction of the Throgs Neck Bridge began in 1959 and opened to traffic on January 11, 1961, at a total cost of $92 million. The bridge was named in honor of John Throckmorton (1601–1684), the colonist who led a group of 35 families to claim the southeastern peninsula in the Bronx in 1642. However, Throckmorton and the other settlers were forced to abandon Throgs Neck after the indigenous people, known as the Siwanoy, attacked their settlement.

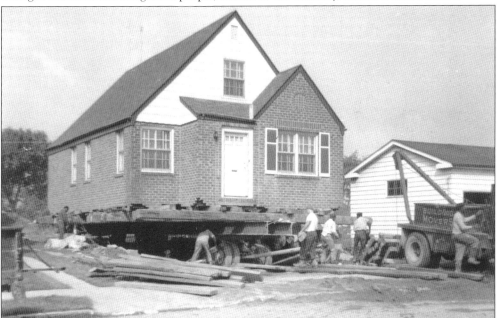

In 1956, final plans for the construction of the Clearview Expressway were made public. As the 5.3-mile expressway was designed to connect the Throgs Neck Bridge approach to the Long Island Expressway interchange at Seventy-third Avenue and terminate at the Grand Central Parkway, homeowners in the path of construction had the option of either having their homes relocated or taking a cash settlement. This photograph from 1959 shows a house on 207th Street between Thirty-second and Thirty-third Avenues being readied for transport to its new location.

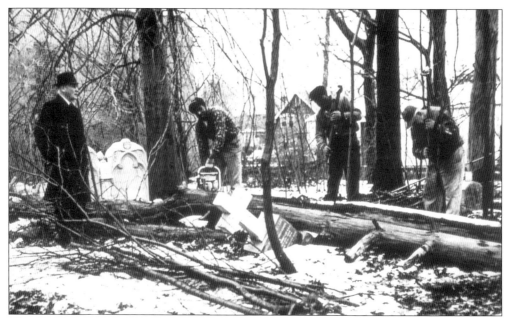

The Lawrence Family Cemetery at 216th Street and Forty-second Avenue was part of the original land granted to John Lawrence by the Dutch in 1645 and was used by the family as a picnic ground, referred to as Pine Grove. The first burial at the site was in 1832. In 1840, Judge Effingham Lawrence drafted a document declaring that any member of the family be allowed burial at the graveyard. He also decreed that the property never be sold. After the last interment in 1939, the cemetery was abandoned. Community leader Joseph H. Brown (left), seen in the 1966 photograph above, spearheaded clean-up efforts and advocated for landmark status for the cemetery, which was achieved in August 1967. The Lawrence Family Cemetery is now maintained by the Bayside Historical Society.

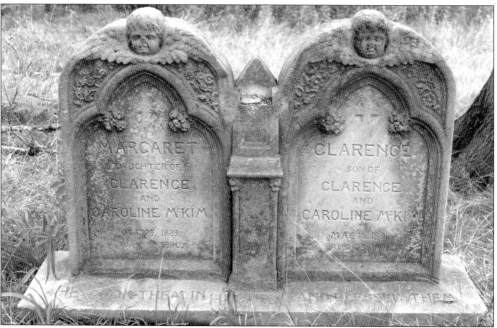

Eight

ACTORS' ROW

At the end of the 19th century and beginning of the 20th century, Baysiders began to see an influx of people moving to town who were associated with the theater and movie industries. Actors, producers, directors, and theater owners were drawn to Bayside for perhaps the same reasons most settled in the area.

Two additional reasons may have also influenced their arrival and established Bayside as a colony for stage and screen stars. The Manhattan-based Lambs Club, which, at the time, was a men's only theatrical organization, had in its membership two Bayside residents, Joseph Grismer (1848–1922) and Clay M. Greene (1850–1933). Not only did each become president of the club, referred to as the "Shepherd of the Lambs," but they also had adjoining properties overlooking Little Neck Bay. On more than one occasion, Grismer and Greene jointly held club parties, called the "Washing of the Lambs," at their summer residences for a few hundred men. No doubt, many were introduced to Bayside through these outings.

When rumors and speculation ran rampant through the acting community that Bayside would be the location of a new movie and production studio, many responded by purchasing homes in anticipation of the opportunities and easy commute. It was only after the studio never materialized, and Hollywood began to emerge as the capital of the film industry in the 1920s, that most actors left Bayside and followed the studios to California in order to pursue their careers.

Many within the acting community not only shared similar lifestyles and careers, but these men and women also enjoyed a commonality of place that Bayside provided. It is evident that most knew one another well. They socialized together, worked together—a few even married—and several became business partners. Not all of the names and faces are familiar (nor is this roster inclusive), yet these Baysiders were popular personalities in their day with notable accomplishments in the performing arts.

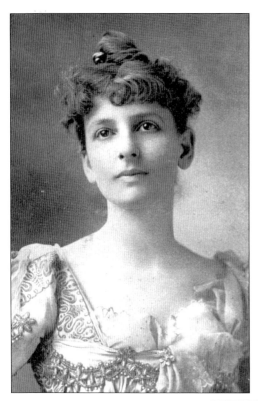

May Robson (1858–1942) lived at 42–34 209th Street, which was sometimes referred to as the "Property," and shared with Marie Dressler the unofficial title of "Dowager Queen of the American Stage and Screen." Robson had only one child, Edward Gore Jr., by her first husband. Her second husband, Dr. Augustus Brown, was a police surgeon. Although Robson appeared in over 60 films, she is perhaps best remembered for her role as Apple Annie in Frank Capra's *Lady for a Day*, for which she received a best actress Oscar nomination in 1933.

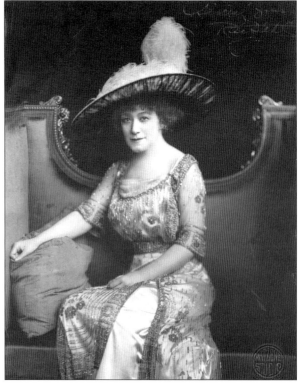

Rose Stahl (1870–1955) was a popular Broadway star at the dawn of the 20th century. Her two most famous hits were the 1906 production of *The Chorus Lady* and the 1911 production of *Maggie Pepper*. By the age of 25, Stahl was married twice. Shortly after her divorce from her first husband, E. P. Sullivan, Stahl married actor William Bonelli in the summer of 1895. Stahl retired from the stage in 1918. She and her third husband, Ollie Alger, settled in Bayside, where she remained until her death in 1955.

Although Andrew Mack (1863 1931) was a singer, composer, lyricist, and producer, he is best remembered as a comedian who performed on the stage for over 50 years. Born William Andrew McAloen, Mack took his stage name when he first appeared in vaudeville performances. His second marriage was to actress Catherine Humphrey. The couple lived on Bayview Avenue until Mack's death in 1931 at the age of 67.

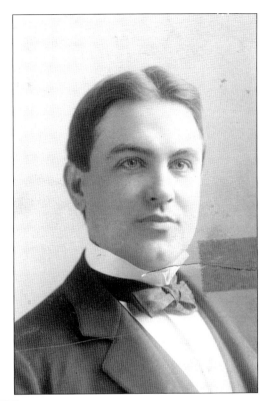

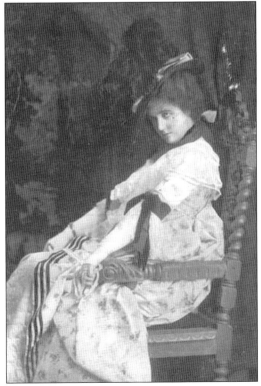

Born Gertrude Lamson, stage and film actress Nance O'Neill (1874–1965) starred in 34 movies between 1913 and 1932 and is perhaps best remembered for her role as Irene Dunne's mother in *Cimmaron*. Although she and her husband, actor Alfred Hickman (1872–1931), resided in Bayside for several years, O'Neill had what was rumored to be an intimate relationship with accused murderer Lizzie Borden between 1904 and 1906. Speculation about O'Neill's sexual orientation persisted throughout her life.

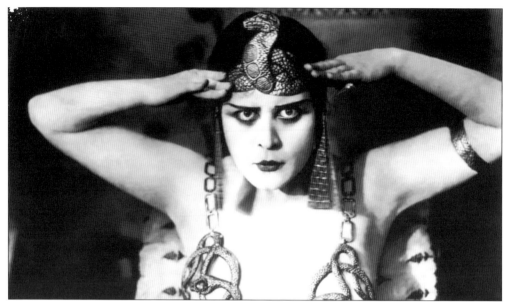

Known as "the Vamp" from her leading role in the 1915 film, A Fool There Was, silent screen legend Theda Bara (1885–1955) lived at 209–07 Forty-third Avenue in Bayside. Her exotic persona of the daughter born to an artist and an Arabian princess was completely fabricated. Her publicists even perpetuated the myth that her name was an anagram for "Arab Death." Bara's success continued after her New York years. She left for Hollywood in 1917 and went on to make an additional 20 films, although only three of her 40 films remain completely intact.

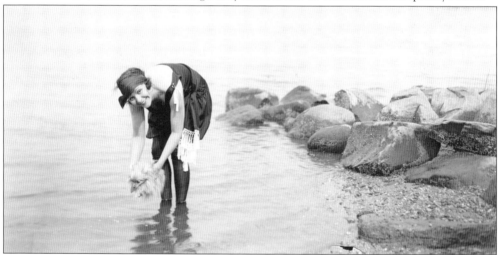

Silent film star Norma Talmadge (1893–1957), seen here on Little Neck Bay with her pet dog, married movie producer Joseph Schenck (1876–1961) in 1916, and together they spent their summers in what was known as the Ridenour Estate. The six-bedroom Colonial house, located at 35–15 222nd Street, overlooks the bay. One of her younger sisters Natalie Talmadge married Buster Keaton in 1921. The wedding took place at the Talmadge/Schenck home in Bayside. Schenck financially backed his wife's production company, but shortly after their move to California in 1921, Talmadge and Schenck divorced. He eventually became the president of United Artists and cofounded the Academy of Motion Picture Arts and Sciences, while Talmadge's film career faded after two unsuccessful talkies.

Stage actor Cyril Scott (1866–1945) lived with his wife, Louise Eising Scott (died 1921), in Bayside until his death in 1945. His oddly-shaped property, known as Long Acre, was situated next to Bayside Gables. It extended from a narrow width of 20 feet at Bell Avenue and continued down to the bay, where it reached its greatest width of 90 feet. Scott, like so many other theatrical residents in Bayside, was a member of the Lambs Club.

MAURICE COSTELLO

Considered the first great matinee idol of the silver screen, Maurice Costello (1877–1950) lived on Willets Point Boulevard with his wife, Mae Costello (around 1882–1929), and two daughters, Dolores Costello (1903–1979) and Helene Costello (1906–1957). Maurice appeared in his first movie in 1905 and later signed with Vitagraph Film Company, a New York–based movie company, before relocating to Hollywood. Although extremely successful in the second and third decades of the 20th century and credited with appearing in over 250 movies, Costello was in financial ruin by the 1930s, and it was reported he sued his daughters for support.

Dolores
Costello

Before Dolores Costello (1903–1979) (left) was called the "Goddess of the Silver Screen," she and her sister, Helene Costello (1906–1957) (below), were child actresses who appeared together with their father for the Vitagraph Film Company between 1909 and 1915. After moving to Hollywood and signing with Warner Brothers Studios, Dolores met and married John Barrymore, uniting these two theatrical families. She was the mother of John Drew Barrymore and the grandmother of actress Drew Barrymore.

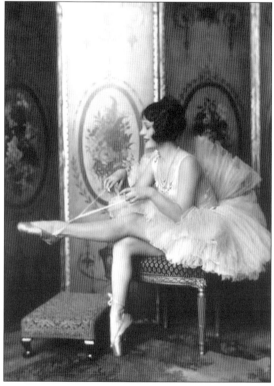

From 1919 to 1921, W. C. Fields (1880–1946) lived at 35–25 223rd Street. It was at this time that he perfected his vaudeville routines and performed in the *Ziegfeld Follies* with fellow Baysider Ray Dooley. Fields returned to Bayside as Prof. Eustance McGargle for the filming of *Sally of the Sawdust* with his costar Gloria Swanson in 1925. Directed by W. D. Griffith, the movie featured Bayside and particularly Forty-second Avenue and Bell Boulevard as the backdrop for the fictional town, Green Meadow.

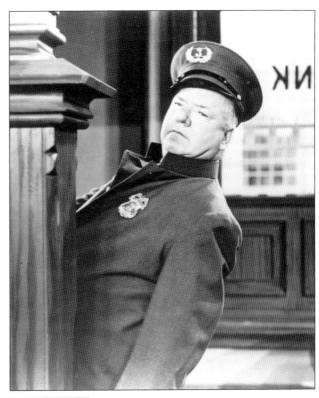

Actor, producer, and director Eddie Dowling (1895–1976) married vaudevillian Ray Dooley (1896–1984). Dooley retired from public life in order to raise her two children, Jack and Maxine. The family lived on Thirty-fifth Avenue and 223rd Street in Bayside, a home they purchased from producer John Golden upon his move to the 17-acre estate he bought from Pearl White in 1920. (Courtesy of the Library of Congress, Prints and Photographs Division.)

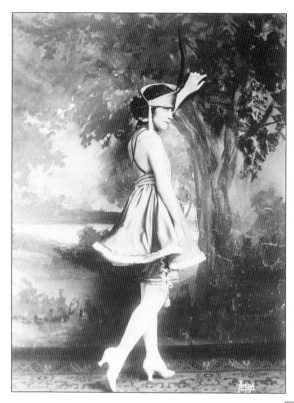

Flora Parker (1883–1950) and Carter DeHaven (1886–1977) were the husband and wife vaudeville team who rarely performed apart and transitioned into movies almost effortlessly. They lived on the corner of Fortieth Avenue and 214th Place before relocating to Los Angeles. Although they divorced, remarried, then divorced again, the couple raised two children, Carter DeHaven Jr., a movie producer and director, and film actress Gloria DeHaven. (Left, courtesy of the Library of Congress, Prints and Photographs Division.)

CARTER DEHAVEN

Nancy Carroll (1903–1965) began her career performing in Broadway musicals. Because of her voice, she was able to transition easily to talkies. Before her move to California, Carroll had a home on Wright Street (209th Street) in Bayside. By 1926, she moved to Hollywood. Although she starred in only eight movies, Carroll was nominated for an Academy Award for best actress in *The Devil's Holiday* in 1930. She retired from her film career in 1938 and returned to the stage.

Comedian Marie Dressler (1869–1934), began her career with a touring company when she was 14 years old. Dressler performed on the vaudeville stage, appeared in musical productions, and went on to star in numerous movies. In 1930 at the age of 63, she received an Academy Award for best actress for her performance in *Min and Bill*. Dressler was also the first woman to be featured on the cover of *Time* magazine in 1933. Her Bayside residence was a Victorian-style house on 219th Street. (Courtesy of the Library of Congress, Prints and Photographs Division.)

At the age of 19, English-born silent screen actress Lillian Rich (1900–1954) came to New York through her Canadian husband, Lionel Edward Nicholson, whom she met while he was serving overseas during World War I. Upon her arrival in New York, Rich immediately began acting and was featured in over a dozen films between 1919 and 1922. It was during these years that Rich listed her address as Bayside, divorced her husband, and continued to pursue her career with her most important role as femme fatale Flora in Cecil B. DeMille's *The Golden Bed* in 1925. Rich eventually left for California only to play matronly roles in the *Our Gang* series of the 1930s. (Courtesy of the Library of Congress, Prints and Photographs Division, Arnold Genthe Collection.)

Usually performing her own stunts and starring in over 200 movies, Pearl White may best be remembered for her role in the *Perils of Pauline* series of 1914. White purportedly earned $3,000 a week during this time. She lived in a grand estate overlooking Little Neck Bay and was occasionally seen around town walking her pet pig. White lived in Bayside until her divorce from her husband, actor Wallace McCutcheon, in 1920. She subsequently sold the estate to producer John Golden and moved to France, where she made her last film in 1924. White remained in France for the rest of her life and died of cirrhosis of the liver at the age of 49. (Courtesy of the Library of Congress, Prints and Photographs Division.)

Ned Wayburn (1874–1942), seen at center, was one of the most well known and influential choreographers of his day. Best remembered for staging the *Ziegfeld Follies* and the *Midnight Frolics* at the New Amsterdam Theatre in Manhattan, he is also credited with producing and choreographing over 500 revues and musical comedies. Wayburn lived on Twenty-sixth Avenue in the Bay Side Park development. (Courtesy of the Library of Congress, Prints and Photographs Division, Bain Collection.)

Nine

PARADES, CELEBRATIONS, AND EVENTS

The community spirit of Bayside's residents is evident through the many celebrations and events that took place over the course of the 20th century. In 1914, civic pride was realized in the form of a grand celebration, simply called Bayside Day, planned by business leaders and the Bayside Civic Association. The celebration featured no fewer than five parades, a bread-baking contest, a barbeque for 3,000 attendees, and an inauguration ball for the queen of Bayside Day, Catharine Reade, who was elected by the residents of Bayside.

Other elaborate festivities were carried out through the years, including the celebration and parade marking the opening of the new fire station in 1913. Honor paid at a stone marker has always been given to Baysider Capt. William Dermody, a fallen soldier of the Civil War, and the opening day celebrations for the new branch library in 1935 included a children's performance with yet another parade. Memorial Day services have also played a role in the community's spirit as did the 1968 classical concert given by the New York Metropolitan Opera in Crocheron Park. Civic pride and community activism were perhaps best realized by participation in A Walk in the Alley, which sparked the public's interest in rehabilitating the Alley beginning in 1969.

Incorporated on December 20, 1890, Bayside's volunteer fire department was known as the Enterprise Hook and Ladder Company No. 1. In 1902, a certificate of incorporation was issued to another volunteer organization, the Bayside Fire Company, and the two consolidated into one fire department. These photographs commemorate Fireman's Day, held on September 1, 1913, which included a parade and dedication of the new fire station located near the public library on Elsie Place (Forty-first Avenue). The Bayside Fire Department ceased operations in 1924 when the City of New York took over fire protection services. The station house was later used by the local Democratic Party, and then by the 111th police precinct. The site is now a municipal parking lot.

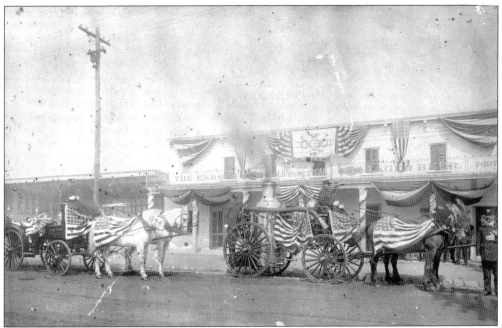

This photograph shows carriages lined up for the parade on Fireman's Day. The building in the background is Fred Engle's Old Homestead, located on the southwest corner of Bell Avenue and Broadway (Northern Boulevard) at the present site of the White Castle restaurant. The hotel not only included a restaurant but also carriage bays, a blacksmith, and a butcher shop.

Volunteer firefighters with the Bayside Fire Department participated in the decorated automobile parade on Bayside Day, September 26, 1914, as seen in this photograph advertising a local business. In another event, the Bayside Fire Department won first prize and a trophy for best appearance by an organization.

This photograph was taken after the baby and children's parades, the first scheduled events of the morning on Bayside Day, September 26, 1914. Marie Dwyer is standing next to her sister, Eleanor Dwyer, seated in the carriage. Marie is holding a trophy awarded to her for participation in the costumed event.

The Bayside Day festivities featured no fewer than five categories of parades, including a baby parade, a children's parade, a civic parade, a decorated-floats parade, and a decorated-automobiles parade. The car in this photograph featured a replica house in the parade of decorated automobiles, no doubt sponsored by a real estate developer.

Wearing a pageant sash in support of establishing a hospital in Bayside is Helen A. Dikes, seen in this photograph along Bell Avenue, on Bayside Day, September 26, 1914.

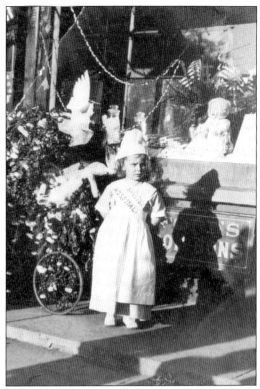

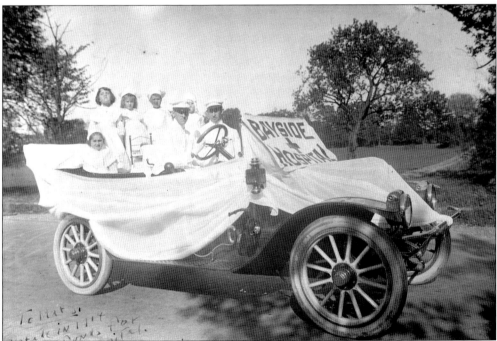

Advocating for Bayside Hospital was this group, featured in the decorated automobiles parade on Bayside Day. Although an attempt to raise funds and support for a local hospital were strong at the dawn of the 20th century, it never materialized.

This group photograph was taken at the beefsteak dinner, held in December 1919, to honor Bayside's veterans. The caption reads, "Tendered in grateful recognition of patriotic service in the world's war to the boys of Bayside."

Crowds gathered to watch the filming of *Sally of the Sawdust* in 1925 starring W. C. Fields (seated in the rear of the car) as Prof. Eustance McGargle under the direction of D. W. Griffith (seated in the chair). In the movie, the fictional town was called Green Meadow, with some of the scenes shot near the train station.

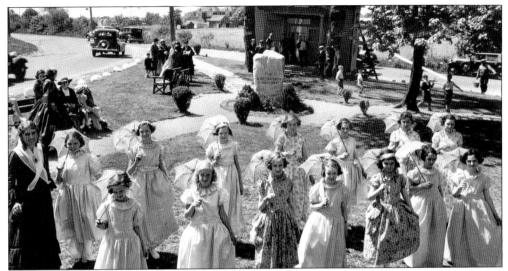

The Memorial Day celebration in 1935 included the rededication of Dermody Square on 216th Street and Forty-eighth Avenue. Named in honor of Capt. William Dermody (1830–1864), an abolitionist and member of the 67th Regiment, New York Volunteers, who was killed while on a mission at Spottsylvania, Virginia, on May 12, 1864. The festivities included a period reenactment, as seen in this photograph, as well as a tree planting ceremony that included a sycamore representing the South and a maple symbolizing the North. A monolithic stone that had been placed on the site by Dermody's sister upon his death simply reads, "For A Better Union 1861–1865."

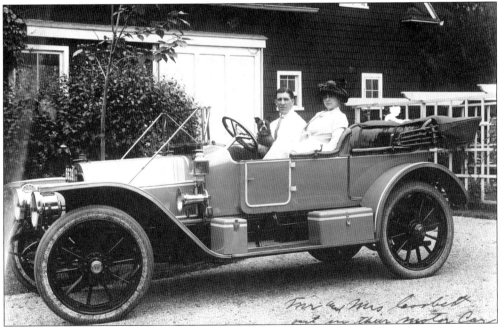

While not a public event per se, Sunday drives were a favored pastime in Bayside. Local lore has it that the actor Cyril Scott was the first Baysider to own a car, having purchased a Cleveland in 1903. In this photograph, boxer James John Corbett (1866–1933) and his wife Vera (died 1959) pose in their new car with Dennie, their pet bulldog.

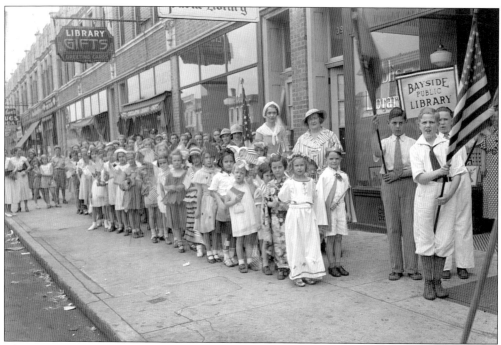

These two photographs were taken on May 15, 1935, the opening day of the new branch library that was moved from Elsie Place (Forty-first Avenue) to Bell Boulevard. The children staged a costumed performance behind the library and participated in a parade to celebrate the event. (Courtesy of the Queens Borough Public Library, Long Island Division, Queens Borough Public Library Collection.)

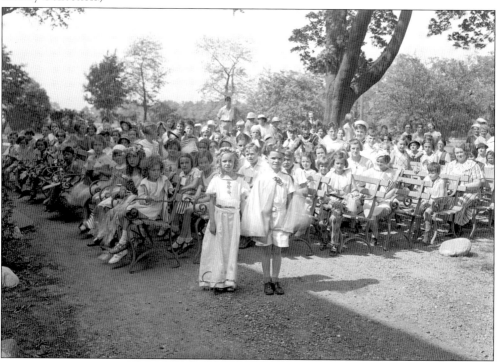

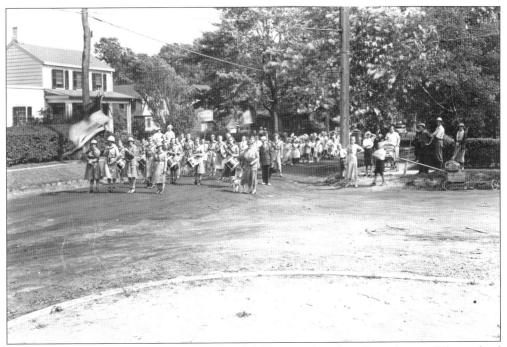

Bayside's Girl Scout troop, followed by school children, marches along Vista Avenue (Thirty-third Avenue) at 210th Street for the parade celebrating the opening day of the new public library on Bell Avenue in 1935.

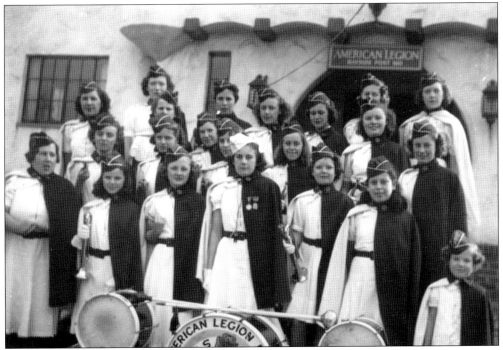

This photograph shows the young women of the American Legion's auxiliary marching band from 1938 standing in front of Post 510 on Thirty-eighth Avenue near Bell Boulevard.

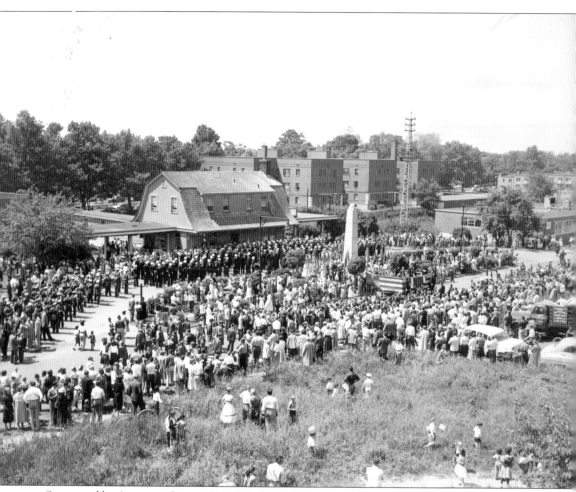

Sponsored by American Legion Post 510, the 1957 Memorial Day services took place at the train station, followed by a parade down Bell Boulevard. The obelisk seen here at the station plaza was dedicated in 1928 as a memorial to the men of Bayside who served during World War I. By 1974, the obelisk was moved to Golden Park. However, because of its remote location, the obelisk suffered from vandalism. It was again moved, and since 1983, it has been on the northeast corner of Northern Boulevard and the Clearview Expressway overpass.

Led by the Alley Restoration Committee, crowds gathered on September 7, 1969, for A Walk in the Alley as a way to show support for the ecologically sensitive wetlands area. Although New York City Parks Department acquired the land in 1929, much of the marshland was filled in, severely debilitating the ecosystem. By 1974, the Wetlands Reclamation Project was created, and efforts to reverse the damage began. In 1976, Alley Pond Environmental Center opened its doors to the public.

Former mayor John Lindsay (1921–2000) (center) and New York City Parks commissioner August Heckscher (1914–1997) (left, with glasses) showed their support by participating in A Walk in the Alley on September 7, 1969.

On June 11, 1968, Bayside listened to the New York Metropolitan Opera perform *Carmen* in Crocheron Park under the direction of maestro Alain Lombard with Franco Corelli as Don José.

Ten

Fort Totten

The peninsula on which Fort Totten is situated was originally deeded to William Thorne by the Dutch in 1640. Known then as Thorne's Point, the name changed to Wilkins Point when Ann Thorne, an heir, married William Wilkins. In 1829, the name changed again, this time to reflect its new owners, Charles and Martha Willet. The federal government purchased 110 acres of Willet's Point for $200,000 from the Willets' heirs in 1857.

Fort Totten was intended to be the companion coastal defense fortification to Fort Schuyler, where both would guard the entrance to New York Harbor from ships approaching via the Long Island Sound. As early as 1821, the federal government conducted a survey of the area and deemed the property suitable for use as a fortification. Although construction of the water battery began in 1862, it was only two years later—before it was even complete—that the battlement was deemed obsolete, as new advances in weaponry were able to easily pierce the masonry walls.

During the Civil War, the fort was known as Camp Morgan, in honor of then New York governor Edwin D. Morgan. Hospitals were built in order to treat wounded soldiers, and the fort served as a staging ground for departing troops. In 1866, Camp Morgan saw its first permanent troops when three companies of engineers arrived along with the Army School of Engineering. In 1898, Camp Morgan was renamed Fort Totten in honor of Maj. Gen. Joseph Totten, who served as chief engineer from 1838 until his untimely death in April 1864 from wounds sustained at the siege of Vera Cruz.

During the 20th century, the Anti-aircraft Command of the eastern defense was headquartered at the fort, and by 1944, it served as headquarters for the North Atlantic region of the Air Transport Command. By the late 1970s, the government declared Fort Totten surplus property, and in 1985, Congress approved the closure of the fort with the National Park Service transferring much of the acreage to New York City Parks Department in 2004. Designated a historic district by the New York City Landmarks Preservation Commission in 1999, Fort Totten Park officially opened to the public in 2005.

Built in the innovative Third or Totten System of fortifications, construction of the battery began in 1862 with William Petit Trowbridge supervising the estimated 400 civilian workers employed at a salary of up to $3.50 a day. The battery was constructed out of granite and forms the shape of a shallow V. (Courtesy of the National Archives and Records Administration.)

Designated a landmark by New York City Landmarks Preservation Commission in 1974, the battlement at Fort Totten is best viewed from Little Neck Bay. (Courtesy of the National Archives and Records Administration.)

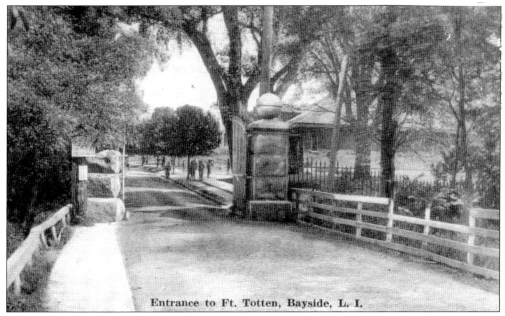

Entrance to Ft. Totten, Bayside, L. I.

The original entrance to the fort was from a road leading off Bell Avenue at its southwestern point. By 1863, the purchase of an additional 26 acres allowed the entrance to be moved to the west end of Totten Avenue. The two granite gateposts seen in this postcard mark the entrance to the fort. They were put in place in 1889. The gateposts are topped by bronze-painted spheres that are disarmed harbor mines.

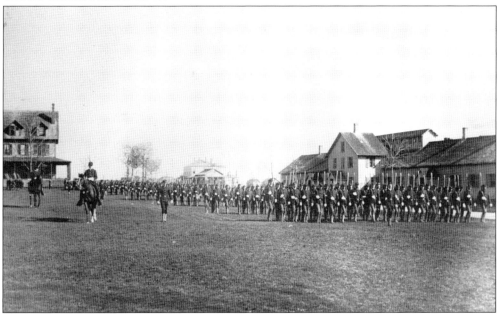

This expansive field was established after the Civil War in 1867. As seen in this photograph from about 1890, the parade grounds originally had a north–south orientation so that the commanding officer's quarters were aligned and centered with the field. It was only after the major building campaign at the fort during the early 20th century that the parade grounds were reconfigured on an east–west axis. (Courtesy of the National Archives and Records Administration.)

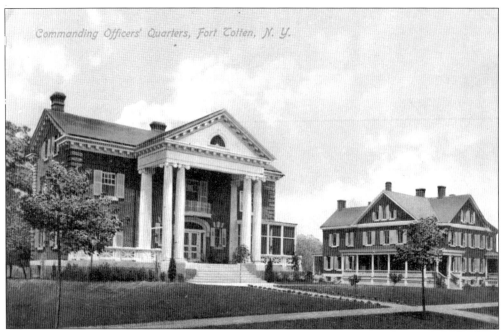

This single-family home overlooking the parade grounds was built in the Colonial Revival style and served as the commanding officer's quarters since 1909. The enclosed porch was added in 1926 on the eastern facade after a fire severely damaged the interior of the building.

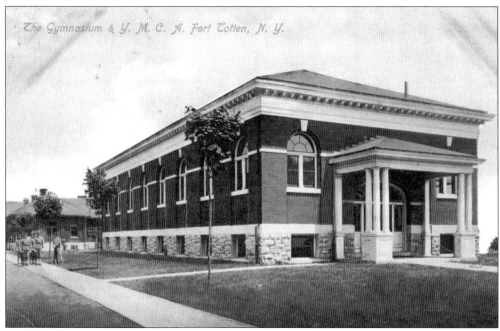

In keeping with the Colonial Revival–style architecture during the building campaign of the early 20th century on the fort, the gymnasium was built in order to meet the recreational needs of the enlisted and noncommissioned officers. The building seen in the distance was built in 1926 as the army YMCA and served as a sports and service facility.

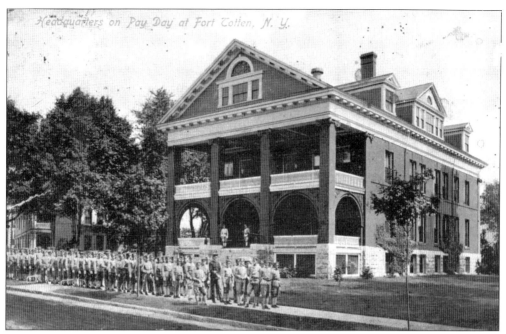

The post headquarters was built in 1905 and served the needs of the expanding fort, including the installation of the coast artillery. The double-story open porch seen in this postcard has since been bricked in. The building in the background was the bachelors' quarters and remained in use until the late 1960s.

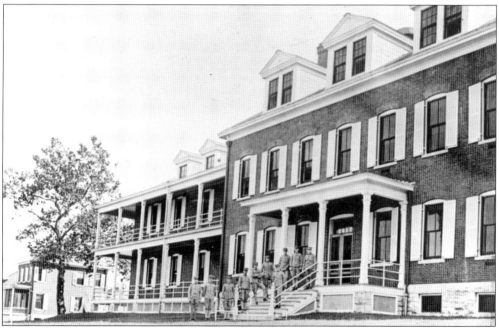

The post hospital was built in 1906 and replaced the older structure named Grant General Hospital, constructed during the Civil War. Seen on the steps are soldiers of the Coast Artillery Corps that moved onto the fort when the eastern artillery district headquarters was established. (Courtesy of the National Archives and Records Administration.)

The Willets Point U.S. Army Corps of Engineers school football team was formed in 1890 and played not only against other military institutions, including West Point and Fort Adams of Rhode Island but also area colleges and athletic clubs, including Fordham University, St. John's College, and the Lenox Athletic Club of Harlem, with the parade grounds at Fort Totten serving as their home field. (Courtesy of the National Archives and Records Administration.)

This photograph of the engineers' baseball team was taken on the steps of the east portico of the officers' club in 1890, the same year they won the army league baseball championship. Like the football team, the baseball team used the parade grounds as their field and the Bayside community was always welcome onto the fort to watch the games. (Courtesy of the National Archives and Records Administration.)

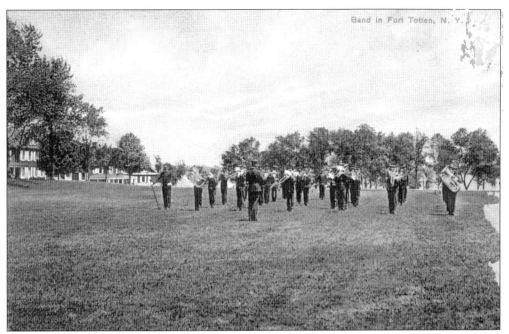

This postcard features the marching band on the parade grounds. It dates after 1906, as that was the year the twin dwelling captains' quarters, seen on the left side of the image, were built.

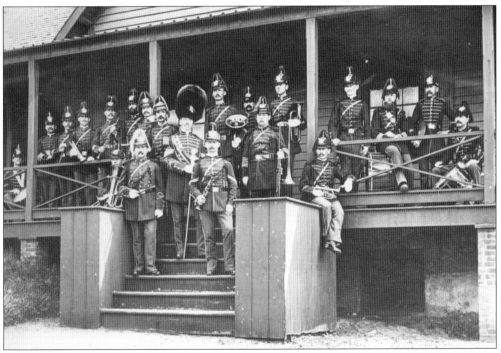

The engineer band posed for this 1880 photograph on the porch of the photography laboratory. The band not only performed during military functions and parade reviews but was also asked to provide music at weddings and other receptions held on the fort. (Courtesy of the National Archives and Records Administration.)

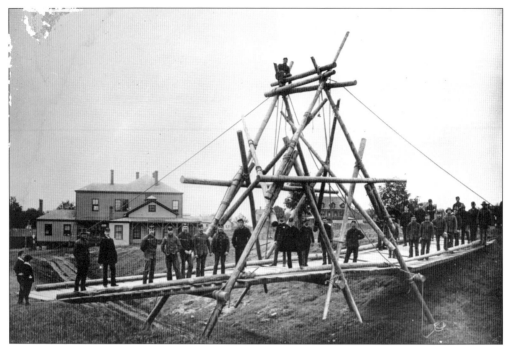

A class on bridge construction from the engineers' school of application is seen in this photograph from about 1890. Graduates from West Point came to Fort Totten for a two-year term in order to study practical engineering. (Courtesy of the National Archives and Records Administration.)

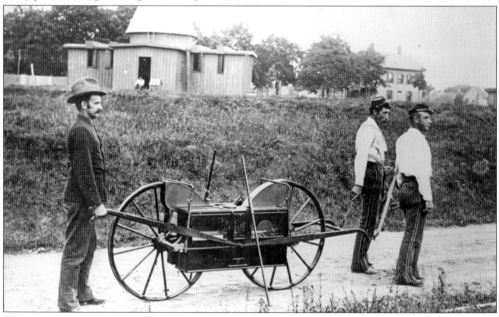

This photograph features a linear measuring device developed at the school of application around 1880. Engineers were also instructed in demolition techniques, submarine mining, and torpedo defense. The building seen in the background had a circular room with a sand floor so that models, such as batteries and other weaponry, could be tested on a scale of one-sixth of an inch. (Courtesy of the National Archives and Records Administration.)

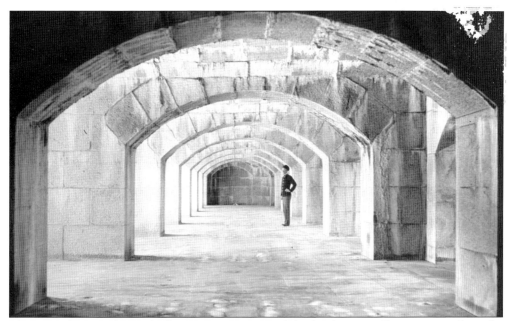

This view features the vaulted interior casements of the battlement. The openings along the casements, known as embrasures, were built into the thickness of the walls and used to house guns. It was Maj. Gen. Joseph Totten who discovered a system whereby the embrasures could be reduced in size, thereby protecting the gunnery crew, and still allow for a 60-degree lateral movement of the weaponry. (Courtesy of the National Archives and Records Administration.)

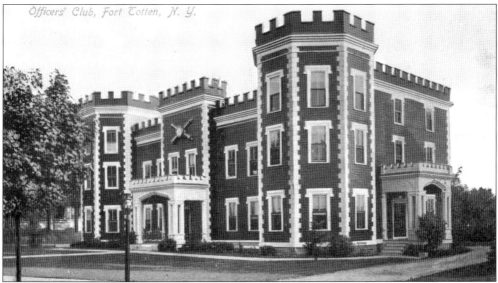

The officers' club was built in 1887 in the castellated Gothic Revival style and replicates the emblem of the U.S. Army Corps of Engineers. Designated a New York City landmark in 1974, the officers' club was placed on the state register and National Register of Historic Places in 1986. The Bayside Historical Society has undertaken the responsibility of restoring the building, and "the Castle," as it has become known, is headquarters for the Bayside Historical Society and home to exhibits, cultural programs, events, and an archival repository documenting the history of Bayside.

www.arcadiapublishing.com

Discover books about the town where you grew up, the cities where your friends and families live, the town where your parents met, or even that retirement spot you've been dreaming about. Our Web site provides history lovers with exclusive deals, advanced notification about new titles, e-mail alerts of author events, and much more.

MADE IN THE USA

Arcadia Publishing, the leading local history publisher in the United States, is committed to making history accessible and meaningful through publishing books that celebrate and preserve the heritage of America's people and places. Consistent with our mission to preserve history on a local level, this book was printed in South Carolina on American-made paper and manufactured entirely in the United States.

This book carries the accredited Forest Stewardship Council (FSC) label and is printed on 100 percent FSC-certified paper. Products carrying the FSC label are independently certified to assure consumers that they come from forests that are managed to meet the social, economic, and ecological needs of present and future generations.

FSC
Mixed Sources
Product group from well-managed forests and other controlled sources

Cert no. SW-COC-001530
www.fsc.org
© 1996 Forest Stewardship Council

Find Your Place in History.